Cosmopolitanism in the Tang Dynasty

A Chinese Ceramic Figure
of a Sogdian Wine-Merchant

Suzanne G. Valenstein

Los Angeles

Cosmopolitanism in the Tang Dynasty: A Chinese Ceramic Figure of a Sogdian Wine-Merchant
Copyright © 2014 by Suzanne G. Valenstein

Distributed by
Transaction Publishers
10 Corporate Place South, Suite 102
Piscataway, NJ 08854

All rights reserved. Exclusive English language rights are licensed to Bridge21 Publications, LLC. No part of this book may be used or reproduced in any matter whatsoever without written permission from the publisher except in the case of brief quotations embodied in critical articles and reviews.

For information contact
Bridge21 Publications, LLC
11111 Santa Monica Blvd, Suite 220
Los Angeles, CA 90025

Published in the United States

Designed and produced by Vern Associates, Inc., Amesbury, Massachusetts
www.vernassoc.com

Composition by Matt Mayerchak, Mayerchak & Company, LLC, Needham, Massachusetts
www.mayerchak.com

Printed and bound by Four Colour Print Group, Louisville, Kentucky

ISBN 978-1-62643-035-8

Contents

Preface — *vii*
Chronology — *ix*
Maps — *x*
Introduction — *xv*

Chapter 1 Attribution — 1
 Analogous Figures — 1
 The Duan Boyang Head and the Croës and Musée Cernuschi Figures
 The Rosenkranz and Royal Ontario Museum Figures
 The Duan Boyang Figure
 Dating — 3

Chapter 2 Sogdians ("*Hu Ren* Westerners") and Turkic Nomads — 7
 Hu Ren **Westerners** — 7
 Sogdians — 8
 The Rosenkranz Figure
 The Duan Boyang Head and the Croës and Musée Cernuschi Figures
 The Turkic Eurasian Nomads — 10
 China and the Turkic Eurasian Nomads
 The Sogdians and the Turkic Eurasian Nomads
 China and the West: The Silk Road — 11

Chapter 3 Western Wine-Merchant Figures and Wine — 15
 Western Wine-Merchant Figures — 15
 Wine — 15

Chapter 4 Ceramic Technology — 17
 Ceramic Tomb Figures: Construction — 17
 The Rosenkranz and Royal Ontario Museum Figures
 The Croës and Musée Cernuschi Figures and the Duan Boyang Head
 The Development of Northern Chinese Ceramic Wares — 18
 The Clays of China
 Early Northern Chinese Porcelaneous Wares
 Early Northern Chinese Porcelaneous Tomb Figures
 Early Northern Chinese Lead-Glazed Earthenwares
 Tang-Dynasty Glazed-and-Painted Earthenware Tomb Figures
 Tang-Dynasty Sancai (Three-Color) Glazes

Kiln-Complexes 20
The Liquanfang Kilns
The Tongchuan Kilns
The Gongyi Kilns
 The Gongyi Baihe Kilns
 The Gongyi Huangye Kilns

Chapter 5 *Mingqi* Figures 25
Mingqi 25
Religious Beliefs 25
From Human Sacrificial Victims to Porcelaneous Figures of Western Merchants 26
The First Emperor's Mingqi
The Han Dynasty
The Six Dynasties Period
The Sui Dynasty
The Tang Dynasty
 Glazed-and-Painted Earthenware Figures
 Sancai (Three-Color) Glazed Earthenware Figures
 Porcelaneous Figures

Chapter 6 Ornamental Motifs 35
The Ornaments 35
Tasseled Streamers Issuing from an Ornamental Disk
The Motifs in the Epaulets: The Rosenkranz and Royal Ontario Museum Figures
 The Pearled Roundel
 The *Makara*
The Motifs in the Epaulets: The Croës and Musée Cernuschi Figures
 The Monster-Mask
 The Five-Petaled Palmette
The Dragon Set in a Pearled Roundel
China and the West: Cultural Influences 39

Chapter 7 Observations 43

Figures 46

Glossary of Ceramic Technology 73
Photograph Credits 75
Key to Shortened References 77
Index 85

Preface

In 1998, I discovered a large, sixth-century Chinese, ceramic mortuary container sitting on the floor at the rear of a small shop in New York's Greenwich Village. I was able to obtain this extremely rare and important object for The Metropolitan Museum of Art. In 2007, the Metropolitan published my study of the vessel, *Cultural Convergence in the Northern Qi Period: A Flamboyant Chinese Ceramic Container: A Research Monograph.* Shortly thereafter, Robert Rosenkranz purchased a large, seventh-century Chinese, ceramic mortuary figure. He suggested that I make this figure, also extremely rare and important, the subject of another research monograph, which eventually became the current publication.

In many respects, my study of the brilliantly sculpted Rosenkranz figure has paralleled my investigation of the Metropolitan Museum's flamboyant container. In researching both the figure and the container, I have made a particular effort to explore every avenue of inquiry—no matter how remote—in the hope of placing these objects into their proper historical settings. (Professor Wen Fong's advice to his students at Princeton University, "Let the art take you where it will," was sage advice, indeed!)

As in all efforts of this kind, a number of people have been of considerable help; and I particularly would like to acknowledge three of them here. First and foremost, I am deeply indebted to Virginia Bower, adjunct associate professor, University of the Arts, Philadelphia, for constantly sharing her encyclopedic knowledge with me. I want to thank Victor Mair, professor of Chinese language and literature, University of Pennsylvania, Philadelphia, most sincerely for his invaluable support of my two research monographs. And I am most grateful to Liu Jie, editor of cultural relics, Cultural Relics Press, Beijing, who has done yeoman work in helping me obtain the necessary permissions to reproduce images from the Chinese publishing houses.

In addition, I would like to acknowledge the incomparable research facilities of the Metropolitan Museum's Thomas J. Watson Library, which always have been available to me; and to express my deep gratitude to Kenneth Soehner, Arthur K. Watson chief librarian, as well as to the entire Thomas J. Watson Library staff, for their ever-present support.

— Suzanne Valenstein

Chronology

NEOLITHIC PERIOD ...? to ca. twenty-first century BC

SHANG DYNASTY ... ca. 1600–ca. 1046 BC

ZHOU DYNASTY .. ca. 1046–ca. 256 BC

 Western Zhou ..ca. 1046–771 BC

 Eastern Zhou ...770–256 BC

 Spring and Autumn Period770–481 BC

 Warring States Period481–221 BC

QIN DYNASTY ... 221–206 BC

HAN DYNASTY ... 206 BC–AD 220

 Western (Former) Han206 BC–AD 9

 Wang Mang InterregnumAD 9–23

 Eastern (Later) Han ...AD 25–220

SIX DYNASTIES (Period of Disunion) ... AD 220–589

 Three Kingdoms ...220–280

 Wu 222–280 Shu 221–263 Wei 220–265

 Western Jin ..265–316

 Eastern Jin 317–420 Sixteen Kingdoms 304–439

 The Period of Southern Dynasties 420–589 and Northern Dynasties 386–581

 Song 420–479 Northern Wei 386–534

 Southern Qi 479–502

 Liang 502–557 Western Wei 535–556 Eastern Wei 534–550

 Chen 557–589 Northern Zhou 557–581 Northern Qi 550–577

SUI DYNASTY ...581–619

TANG DYNASTY ... 618–907

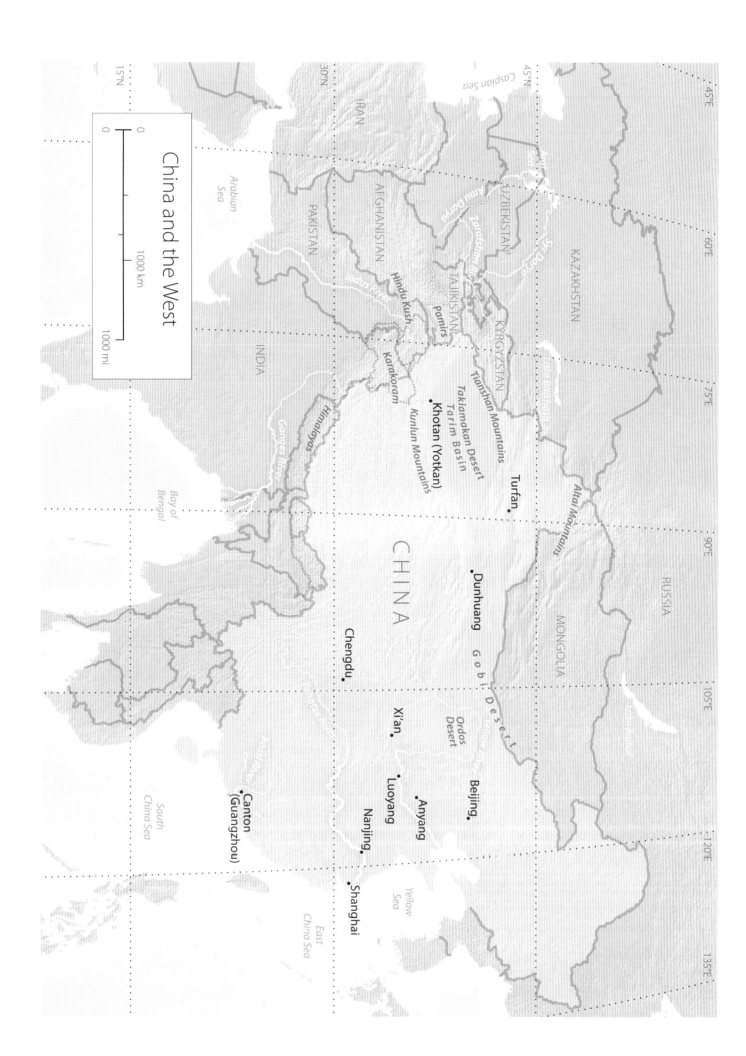

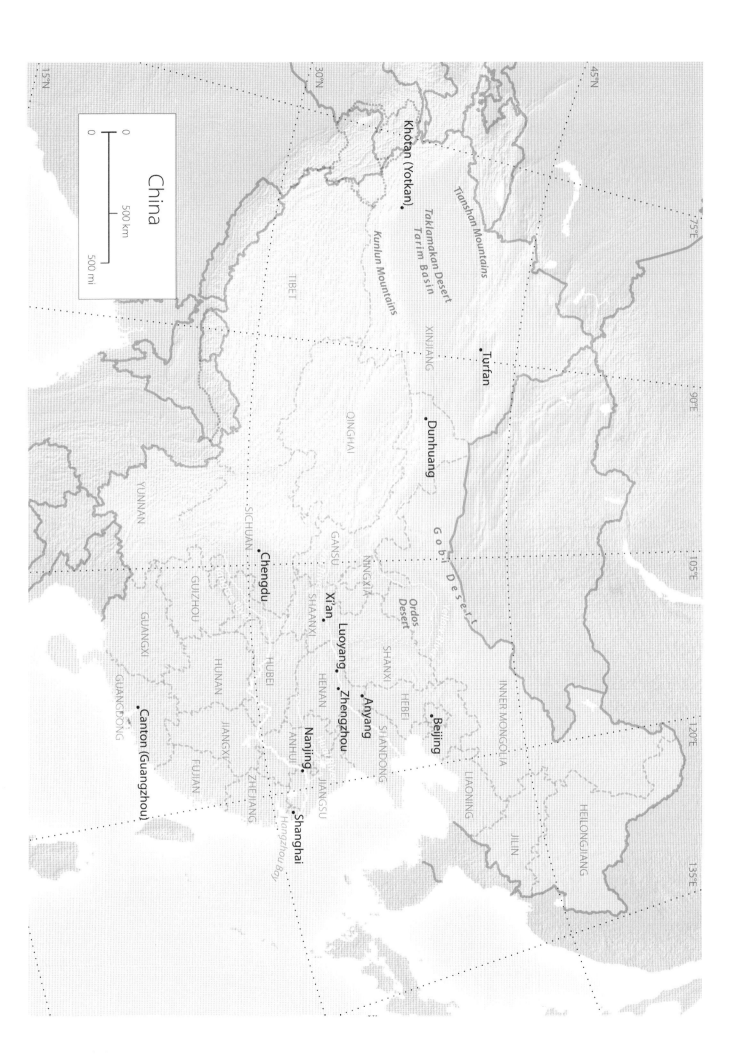

Cosmopolitanism in the Tang Dynasty
A Chinese Ceramic Figure of a Sogdian Wine-Merchant

Introduction

A dramatic, fifteen-inch-high, white porcelaneous figure of a Sogdian wine-merchant in the collection of Alexandra Munroe and Robert Rosenkranz (Figures 1–3) is one of the most remarkable examples of Chinese mortuary sculpture to come to light in recent years. No documented analogous tomb figures appear to have been published to date. However, it clearly belongs to a small, cohesive group of Chinese ceramic figures depicting Western wine-merchants that can be attributed to the early Tang dynasty (618–907).

The fully rounded head of this kneeling male figure was meticulously modeled to emphasize his explicitly depicted, grossly exaggerated features. There is no doubt that this is the distinctive physiognomy of a non-Han Chinese Westerner. His face is dominated by a prominent nose and bulging eyes; the large pupils are punctuated with spots of dark brown. The overstated curvature of his knitted eyebrows is complemented by a similarly curved, thin mustache surmounting his slightly opened mouth. A small hole appears at either end of the mouth. There is an enigmatic triangle of ridges (a pendant?) between his eyebrows. His curly hair is represented by rows of very elaborate scallops; these scallops are more perfunctorily treated on the back of his head. A bifurcated lock of straight hair ends in spirals on his forehead; and the short, heavy beard is shown as rows of knobs. He wears enormous earrings composed of tasseled streamers issuing from ornamental disks.

In contrast to the highly animated head, the figure's sturdy body seems rather static. His right hand clasps a round-bottomed, long-necked vessel with a large foliate mouth, presumably depicting a leather wineskin. Whereas the left leg is tucked under the body, the boot-encased right leg is bent in front in a rather awkward position.

The collar and blouse of his tunic are edged in a simple ribbed band; the short sleeves are edged with fringe-like ribbing. Elaborate epaulets at the shoulders of this garment consist of foliated panels containing a design of confronting fish-like creatures within pearl-beading. A large dragon-roundel, also set in pearl-beading, is just above the waist. The two beaded cabochons on the upper part of the tunic are repeated on his belt. Two cabochons are in the front; three others support pendent ornamented implements in the back; and one anchors an unidentified large, fluted round object at the left hip. Although part of it is missing, the loose end of the belt is looped and tucked under the belt in the back. In addition, what appears to be a large leather pouch is at the figure's right hip.

As seen on the unglazed flat base, the white clay body is fine textured. Although it approaches the hardness of "true" porcelain, it is somewhat porous and might best be classified as porcelaneous ware. The finely crazed, clear glaze is quite uneven and takes on a light khaki green tone where it is thick. It stops in an irregular line an inch or more above the figure's base in the front and runs in khaki-toned streaks to the base in the back.

This research monograph is divided into seven chapters. In the first, it will be seen that the Rosenkranz figure's connections to a small group of analogous tomb figures substantiates the attribution of "early Tang dynasty, ca. 625–675" assigned here to this piece. The next chapter establishes the Rosenkranz figure as an ethnic Sogdian and explores the interrelationship among the Sogdians, the Turkic Eurasian nomads, and China during the Tang dynasty. Chapter 3 concerns Western wine-merchant figures and the history of alcoholic beverages in China. The following chapter discusses ceramic technology: the construction of tomb figures; the development of various types of northern Chinese ceramic wares; and kiln-complexes. The history of Chinese mortuary furnishings, known as *mingqi*, is looked at next, with a particular emphasis on the ceramic surrogate figures of people that were made especially for the elite tombs of northern China, as well as on the various materials used to fabricate these figures. In Chapter 6, the ornamental motifs on the Rosenkranz figure and its analogous examples are traced both chronologically and geographically to their origins. It will be seen that most of these decorative motifs can be found in the West, and most of them also are associated with Buddhism. Some final observations about this splendid porcelaneous caricature of a Sogdian wine-merchant comprise the last chapter.

Chapter 1

Attribution

Analogous Figures

Four complete ceramic tomb figures provide a series of connections—reminiscent of the sociological theory of "six degrees of separation"—that link the Rosenkranz porcelaneous figure (Figures 1–3) to the surviving porcelaneous head of a Sogdian[1] (Figure 4), which originally had been part of a complete figure.[2] This documentary head was found in 1956 in the Tang-dynasty tomb of Duan Boyang, in the suburbs of Xi'an, Shaanxi Province.[3] Duan Boyang had held various high-ranking posts in the Palace Domestic Service during the Sui (581–619) and Tang dynasties.[4] The ceramics in his tomb could have been placed there in either 661 or 667.[5] These connections establish the attribution of "early Tang dynasty, ca. 625–675," given here to the Rosenkranz piece.

These four complete figures are: an undocumented porcelaneous figure (Figures 5–7), formerly in the Gisèle Croës collection, Brussels;[6] a glazed-and-painted earthenware figure (Figure 8) in the collection of the Musée Cernuschi, Paris;[7] a porcelaneous figure (Figures 9–11) in the collection of the Royal Ontario Museum, Toronto;[8] and a documentary, smaller porcelaneous figure (Figure 12) that was found—along with the porcelaneous Sogdian head—in the Tang-dynasty tomb of Duan Boyang.[9] Like the Rosenkranz figure, all four of these complete figures, representing at least two different ethnic groups, are in a kneeling position. The left hand rests on the chest, and a large container invariably is clutched in the right hand. The major ornamental elements of the figures' clothing are executed in appliqué-relief;[10] secondary features, such as folds in fabric, are indicated by incised lines. The collars and blouses of the tunics have simple edging, and the short sleeves are bordered with fringe-like ribbing. Although four different physiognomies are depicted, each figure has a curling mustache. A small hole appears at either end of the mouths; and the pupils of the eyes are emphasized by either painting or incising. The three most relevant ceramic figures, which approximate the size of the Rosenkranz example, have comparable appliqué-relief ornamental motifs.

The Duan Boyang Head and the Croës and Musée Cernuschi Figures

Tracing the series of connections between the surviving Duan Boyang head and the Rosenkranz figure, one sees that the Duan Boyang head, with its very distinctive four-sided, high-crowned hat with shallow, upturned brim (Figure 4), is virtually identical to the head of the Croës complete porcelaneous figure (Figures 5–6). In turn, the glazed-and-painted earthenware figure (Figure 8) in the Musée

Cernuschi is amazingly close to the Croës porcelaneous figure, as well as to the porcelaneous head from the Duan Boyang tomb (Figure 13). The two figures and the head probably were produced in the same northern Chinese kilns at about the same time.[11]

The tunics of the Croës and Cernuschi figures have the same simple edging at the collars and blouses; there are identical grimacing, frontal monster-mask epaulets in appliqué-relief at the shoulders;[12] and the same appliqué-relief dragon-roundels set in pearl-beading are on the chests.[13] These dragon-roundels provide an important connection to the Rosenkranz figure, where the same ornament also appears on the chest.

The Croës and Cernuschi figures both wear deeply incised ribbed belts. A large, fluted round object in high relief hangs from the belt on the left hip of the Croës piece (Figures 5, 7). A very similar large round object can be seen—also on the left hip—as part of a set of appliqué-relief ornamented implements hanging from the relief belts on both the Rosenkranz figure (Figures 1, 3) and the Royal Ontario figure (Figures 9, 11). Unlike the Rosenkranz and Royal Ontario examples, however, there are only two simple low-relief straps hanging from the belt of the Croës figure (Figure 7); the three incised vertical panels on the Cernuschi figure's back probably represent the appliqué implements on its porcelaneous counterpart.[14]

The primary difference between these two figures is that, whereas the Croës porcelaneous figure clutches a ewer that is based on a Sogdian metal prototype,[15] the Musée Cernuschi earthenware example holds a long, hollow object with a faceted, foliated rim, which might be a rhyton.

The prominent noses, bulging eyes, and heavy beards of the Croës and Cernuschi figures—as well as of the Duan Boyang head—are characteristic of the people who are designated *hu ren* Westerners in this study;[16] in this instance, they are ethnic Sogdians.[17] This connects them to the Rosenkranz figure, whose facial features are those of the quintessential *hu ren* Westerner; he also is an ethnic Sogdian.

The Rosenkranz and Royal Ontario Museum Figures

The porcelaneous figure in the Royal Ontario Museum (Figures 9–11), which is most closely related to the Rosenkranz figure (Figures 1–3),[18] offers further, although undocumented, clues to the attribution of the Rosenkranz piece. This figure, together with large quantities of other tomb figures, was sent by the Chinese-art wholesaler George Crofts from China to the Royal Ontario in 1918. It reportedly was found in Guanyintang, Shan xian, in western Henan Province.[19] Guanyintang is about 170 miles east of modern Xi'an, Shaanxi, which during the Tang dynasty was the capital city of Chang'an.

The similarities between the Royal Ontario and Rosenkranz figures (Figures 14–16) are striking;[20] and it is proposed here that these quasi-identical tomb figures were crafted in the same workshop at the same time.

Although the upper part of it is missing, the round-bottomed, long-necked vessel clasped in the Royal Ontario figure's right hand presumably depicts a leather wineskin like that held by the Rosenkranz figure. The same elaborate epaulets, comprising foliated panels containing a design of confronting fish-like creatures within pearled roundels, are at the shoulders of both figures.[21] Beaded cabochons on the tunic of each figure are repeated on the appliqué-relief belt, where they anchor a large, fluted round object at the left hip and a set of ornamented implements in the back (Figure 16). The loose end of the belt is looped and tucked under the belt in the back of the Royal Ontario figure and—although part of it is missing—on the Rosenkranz piece as well. What appears to be a large, ornamented leather pouch is at each figure's right hip (Figures 2, 10).

The body of the Royal Ontario figure has been described as being buff white and fired to stoneware hardness; the glaze as thin, grayish white, finely crazed in parts, and taking on a greenish tint where it is thick, particularly where there are grooves or depressions in the underlying body.[22] This description could almost apply to the body and glaze of the Rosenkanz piece.

The essential difference between these two figures is obvious. The bulging eyes, prominent nose, curly hair, and heavy beard of the Rosenkranz figure are those of the classic *hu ren* Westerner.[23] Conversely,

his slanting eyes, long curved nose, small goatee, and very long strands of braided hair mark the Royal Ontario figure as one of the Turkic nomads of the Eurasian steppes.[24] (However, unlike the Rosenkranz figure, which is a grotesque caricature of an ethnic Sogdian,[25] the Royal Ontario figure is a fairly straightforward representation of an ethnic Turk.) As seen in Figure 17, images of Turkic men with very long hair have been found in two different Turkic kurgans, or burial mounds, which are assigned to the sixth-to-seventh century, in Kudyrge, in the Altai Mountains region of southern Siberia.[26]

The singular appliqué-relief belts with pendent ornamented implements worn by these two ethnically different figures (Figures 16, 18) deserve special attention. It has been explained,

> "Such pendants are a feature specifically associated with Turkic-Mongolian belts. Their use spread from the Turkic tribes on China's northern borders to China as well as to the West, where, by the end of the sixth century, belts with this kind of ornamentation were worn in Central Asian, Sasanian, and Byzantine territories."[27]

As seen in Figure 18, similar Turkic belts with pendent ornamented implements[28] have been found in the two different Turkic kurgans, assigned to the sixth-to-seventh century, in Kudyrge.[29]

The Duan Boyang Figure

The small, complete porcelaneous kneeling figure (Figure 12) is a documentary connection between the Rosenkranz figure (Figures 1–3) and the surviving porcelaneous head of a Sogdian (Figure 4). He was found, along with the Sogdian head, in the Tang-dynasty tomb of Duan Boyang.[30] The curly hair on this complete figure's head is edged with a string of beads, and there is a large dot—representing a Buddhist auspicious mark, the Urna—on his forehead. This young man, like the Rosenkranz figure, is holding what presumably depicts a leather wineskin with a large foliate mouth. Although his facial features are not as exaggerated as they are in some other Chinese tomb figures of foreigners, his curly hair, prominent nose, and deep-set eyes still identify him as a *hu ren* Westerner.

Dating

In order to establish the date of the Rosenkranz porcelaneous figure and its companion figure in the Royal Ontario Museum, one must look to the substantiating Musée Cernuschi and Croës figures, as well as to the documentary Duan Boyang head.

The Cernuschi glazed-and-painted earthenware figure is clearly related to the Croës porcelaneous figure; and they both, in turn, are closely connected to the Duan Boyang porcelaneous head, which is datable to 661 or 667 (Figure 13). It seems logical to deduce that these three substantiating ceramics probably were manufactured at about the same time.[31] Documentary glazed-and-painted earthenware tomb figures have been discovered at several sites:[32] in three attendant burials in the Imperial Cemetery adjacent to Zhaoling, the mausoleum of the Tang-dynasty Taizong emperor (r. 626–649) near today's Xi'an, Shaanxi; in a tomb in the vicinity of Luoyang, Henan; and in another tomb in Chaoyang, Liaoning Province. The dates of these five tombs range from 643 to 664, suggesting a feasible attribution of "ca. 625–675" for the entire family of glazed-and-painted earthenware figures—including the Cernuschi glazed-and-painted example—and, by extension, the matching Croës porcelaneous figure.

Inasmuch as there are many similarities in the fabrication and ornamentation of the Croës figure and those of the Rosenkranz and Royal Ontario porcelaneous figures, it again seems logical to deduce that these two figures—along with the Musée Cernuschi and Croës figures, as well as the documentary Duan Boyang complete figure and residual head—all were made at the same northern Chinese kiln-complex and are more or less contemporary.

Endnotes

1. See "Sogdians" in Chapter 2, Sogdians ("*Hu Ren* Westerners") and Turkic Nomads.

2. Apparently—with the exception of a considerable number of separate earthenware horses' heads found in Han-dynasty tombs—discrete ceramic heads were not included among the Chinese mortuary sculptures.

 As can be seen quite clearly in Figure 4, this head has been extensively repaired; therefore, it must have been severely damaged in the past. Inasmuch as the identical head remains on two complete ceramic tomb figures (Figure 13), we can assume that this head originally was part of a similar intact figure, but the body probably was beyond repair.

3. Shaanxi 1960, frontispiece fig. 3. This head is 6½ in. (16.6 cm) high.

4. Including director of the Palace Gates Service, Heir Apparent Household manager, military protector, and senior steward to the Palace Domestic Service.

5. Duan Boyang was buried in 661; however, the tomb was not sealed until his spouse was buried with him in 667. Three porcelaneous objects were found in this tomb, but it is not certain when they were placed there. It is currently believed that, in view of Duan Boyang's importance, these porcelaneous objects were interred with him in 661 (Luoyang 2010). I am most grateful to Marilyn Shea for finding this reference, and to Virginia Bower for helping to analyze it.

6. Croës 2008b. This figure, which now is in the R. A. collection, is 20⅞ in. (53 cm) high. It might have come from the same tomb as the Rosenkranz figure.

7. Béguin, Maucuer, and Chollet 2000, 108–109; Bobot 1983, 42–43. This figure is 15¾ in. (40 cm) high. It was acquired by the Musée Cernuschi in 1960.

8. Royal Ontario 1992, no. 25; Proctor 1979, fig. 11; Trubner 1962, figs. 1–2. This figure is 14⅞ in. (37.7 cm) high. I thank Virginia Bower for calling my attention to this very important figure.

9. Shaanxi 1960, frontispiece fig. 2. This figure is 9¼ in. (23.5 cm) high. Also found in the tomb was a porcelaneous high-footed globular bowl with appliqué-relief medallions. Its finely crazed, clear glaze has a greenish tone where it is thick (ibid., fig. 1). This bowl is 9⅛ in. (23 cm) high.

10. See "Ceramic Tomb Figures: Construction" in Chapter 4, Ceramic Technology.

11. See "The Croës and Musée Cernuschi Figures and the Duan Boyang Head" in Chapter 4, Ceramic Technology.

12. See "The Motifs in the Epaulets: The Croës and Musée Cernuschi Figures" in Chapter 6, Ornamental Motifs.

13. The Croës figure has two dragon-roundels; the Musée Cernuschi figure has only one. See "The Dragon Set in a Pearled Roundel" in Chapter 6, Ornamental Motifs.

14. I thank Eric LeFebvre and Alfreda Murck for photographing this figure for me.

15. Ewers having the upper part of the handle attached to the rim are based on Sogdian metal prototypes (Juliano and Lerner 2001a, 316, fig. a); whereas those having the upper part of the handle attached to the ewer's body are based on Sasanian originals (ibid., 316).

 A porcelaneous ewer in the Shanxi Museum is very similar to the one being held by the Croës porcelaneous figure. This Shanxi Museum ewer, which is 12¼ in. (31.2 cm) high, has been attributed to the Tang dynasty; it was excavated in 1956 near Taiyuan city, Shanxi Province (Zhang Bai 2008, fig. 47). Both the ewer held by the Croës figure and the Shanxi Museum ewer are based on Sogdian silver prototypes, such as the one excavated in 1975 at Aohan Banner, Liaoning Province (Aohanqi 1978, pl. 8:2–3, fig. 1). Although that silver ewer was found in a tenth-century Liao-dynasty tomb, it has been attributed to seventh-century Sogdiana (Marshak 2004). Particularly noticeable is the full-relief image of a young man's head at the top of the silver ewer's handle: his features have been described as "unmistakably Sogdian" (ibid.).

16. See "*Hu Ren* Westerners" in Chapter 2, Sogdians ("*Hu Ren* Westerners") and Turkic Nomads.

17. See "Sogdians" in Chapter 2, Sogdians ("*Hu Ren* Westerners") and Turkic Nomads.

18. This figure is 14⅞ in. (37.7 cm) high. The Rosenkranz figure is 15 in. (38 cm) high.

19. Royal Ontario 1992; Proctor 1979; Trubner 1962.

20. See also "The Rosenkranz and Royal Ontario Museum Figures" in Chapter 4, Ceramic Technology.

21. See "The Motifs in the Epaulets: The Rosenkranz and Royal Ontario Museum Figures" in Chapter 6, Ornamental Motifs.

22. Trubner 1962, 100–101.

23. See "*Hu Ren* Westerners" in Chapter 2, Sogdians ("*Hu Ren* Westerners") and Turkic Nomads.

24. Royal Ontario 1992, no. 25, where it is noted, "Turkic Uighur noblemen of like appearance, with neat goatees, trimmed mustachios, and long strands of hair, were painted on the walls and banners of the monasteries of Central Asia." (As it is here, the designation "Uighur" frequently has been applied to all Turkic nomadic tribes.

However, it should be remembered that the Uighurs were but one of many tribes in the Turkic tribal confederations, and they did not establish their own Uighur Empire until 744.) See "The Turkic Eurasian Nomads" in Chapter 2, Sogdians ("*Hu Ren* Westerners") and Turkic Nomads. See also Mahler 1959, 38–42.

25 See "Sogdians" in Chapter 2, Sogdians ("*Hu Ren* Westerners") and Turkic Nomads.

26 Pletneva 1981, 127–128, figs. 22–23.

27 Juliano and Lerner 2001a, cat. no. 91. See also Royal Ontario 1992, no. 25, where it is noted, "Turkic Uighur noblemen . . . wear belts decorated with disks and pendant tabs from which hang articles of daily use. This military figure sports a pouch to each side and a dagger across his belly, its sheath suspended from two points in foreign fashion."

28 Notice in particular the belts, nos. 6–7 (bottom), which also have beaded cabochons anchoring the pendent elements.

29 Pletneva 1981, 128–129, fig. 23.

30 A larger porcelaneous kneeling figure with curly hair, prominent nose, deep-set eyes, a conspicuous curling mustache, and minimal decoration on his clothing, is quite similar to the Duan Boyang example. This larger figure, which also is holding what presumably is a very big wineskin, is 14 in. (35.6 cm) high; it was sold at Sotheby Parke Bernet, London, on Tuesday, December 12, 1978, lot 325. It probably is the one now in the Idemitsu collection, Tokyo (Idemitsu 1987, fig. 355).

31 See "The Croës and Musée Cernuschi Figures and the Duan Boyang Head" in Chapter 4, Ceramic Technology.

32 See "Glazed-and-Painted Earthenware Figures" in Chapter 5, *Mingqi* Figures.

Chapter 2

Sogdians ("*Hu Ren* Westerners") and Turkic Nomads

Hu Ren Westerners

At one time, the Chinese term *hu*, usually translated as "barbarian," referred generally to all non-Han Chinese people.[1] By the Sui and Tang periods, however, the term *hu* had come to refer specifically to those non-Chinese people with origins in the so-called Western Regions.[2] In particular, the Sogdians and Persians were called *hu* more often than any other non-Han group.[3] These *hu ren*, or non-Han Westerners, are portrayed in the art of the Sui and Tang dynasties as having curly hair, heavy beards, deep-set eyes, and prominent noses; the latter two features summarized in the phrase *shenmu gaobi* (deep eyes and high noses).[4]

The distinctive facial features of the Rosenkranz Chinese porcelaneous tomb figure are those of the classic *hu ren*. He epitomizes the Sui- and Tang-dynasty ceramic craftsmen's convention of obviously caricaturing or exaggerating the physiognomy and expressions of non-Han people: their eyes are either bulging or very big with heavy outlines and large staring pupils; their noses are excessively large; and they frequently appear to grimace or shout.[5]

Very few classic *hu ren* Westerners have been found among Chinese mortuary figures dating to the Six Dynasties period (AD 220–589). Two earthenware standing figures of hirsute men with very prominent proboscises were discovered in 1965 in Luoyang, Henan Province, in the Northern Wei-dynasty (386–534) tomb of Yuan Zhao, prince of Changshan (d. 528).[6] Also notable is the ceramic head of a hirsute man with a big nose and deep-set eyes found in the pagoda of the late Northern-Wei (ca. 494–534) Buddhist Yongning Temple, in Luoyang.[7] Although other Six Dynasties figures labeled *hu* in archaeological reports do have non-Han features—such as the seven figures found in the Eastern Wei-dynasty (534–550) tomb of Ruru Princess Linhe (buried 550), excavated in 1978–1979 in Cixian, Hebei Province[8]—they had not yet evolved into the classic *hu ren* caricature being examined here.

In addition to those mortuary figures, four earthenware flattened jars with amber-colored glazes were found in the Northern Qi-dynasty (550–577) tomb of Fan Cui (d. 575), cavalry general-in-chief of the Northern Qi, unearthed near Anyang, Henan, in 1971. These jars are decorated with figures of musicians and a dancer, and several of these figures have the deep-set eyes and high noses associated with the *hu ren*, or non-Han Westerners.[9]

A pair of exquisitely modeled earthenware images of *hu ren* (Figure 19) were among the ninety-five ceramic figures in the Sui-dynasty tomb of General Zhang Sheng (buried 595), which was found in 1959 in Anyang.[10] Although these two figures have the heavy facial hair, deep-set eyes, and prominent noses of a classic *hu ren*, they are sensitive depictions of exotic men, rather than the usual caricatures of foreigners.

A quasi-identical pair of porcelaneous standing court officials (Figure 20), also from the Zhang Sheng tomb, are important as two of the earliest-known, firmly documented examples of porcelaneous mortuary figures.[11] Of additional importance is the fact that the figure to the left has the requisite prominent nose, deep-set eyes, and heavy facial hair—the latter two features emphasized in dark brown—of a classic *hu ren* Westerner.

Two other porcelaneous figures of *hu ren* Westerners were found in 1987 in a tomb in Jiajingkou, some nineteen miles from the city of Gongyi (originally known as Gong xian), also in Henan. Although there is no firm evidence to date this tomb, it has been attributed in the archaeological report to the Sui dynasty.[12]

Tang-dynasty tomb sculptures include a cavalcade of *hu ren* Westerners.[13] These earthenware figures—which can be either unglazed and undecorated; unglazed and painted with unfired pigments; glazed and over-painted with unfired pigments; or covered with the distinctive Tang-dynasty *sancai* (three-color) glazes—include peddlers, grooms, camel drivers, warriors, musicians, and merchants.[14] One of the most spectacular examples is the large *sancai*-glazed piece depicting five musicians atop a camel, excavated in 1957 from the tomb of General Xianyu Tinghui (d. 723), in the suburbs of modern Xi'an, Shaanxi Province.[15] Two of these musicians represent Han Chinese; the other three are archetypes of the classic *hu ren* Westerner.

Porcelaneous mortuary wares found in the Tang-dynasty tomb of Duan Boyang included a figure of a young man (Figure 12).[16] Like the Rosenkranz piece, he is kneeling and holding what apparently is a large leather wineskin. Although his features are not as exaggerated as they are in some other examples, his curly hair, deep-set eyes, and prominent nose still identify him as a *hu ren* Westerner.

Sogdians

The Rosenkranz Figure

The Rosenkranz porcelaneous figure depicts an ethnic Sogdian. The Sogdians were an Eastern Iranian people whose home, Sogdiana,[17] lay in the Zarafshan River valley, between the Amu Darya (or Oxus) and Syr Darya (or Jaxartes) Rivers. This region, sometimes known as Transoxiana, encompasses today's Uzbekistan and part of Tajikistan, an area where the early Chinese, Indian, and Persian civilizations converged.[18] The Sogdians, who spoke a language belonging to the northeastern group of Eastern Iranian languages,[19] were renowned merchants.[20] Much of the Western merchandise that arrived in China was transported by the Sogdians, who dominated commerce on the Silk Road;[21] indeed, Sogdian was the lingua franca of Central Asian commerce until the thirteenth century.[22]

Wherever Sogdian merchants traded, they also settled.[23] As has been explained,

> "Sogdians came to China from the west to trade via the Tarim Basin, the Hexi Corridor, northern China and the Mongolian steppes. They came eastwards to conduct trade in groups ranging from several dozen to several hundred in number and provided themselves with armed protection. They travelled along the traditional Silk Road and many of them remained at various places and formed their own settlements, or established colonies in which they were able to survive."[24]

Pertinent to this study is the longtime presence of Sogdians in Chang'an (modern Xi'an), Shaanxi. Sogdians have been documented in Chang'an as early as the Six Dynasties' Sixteen Kingdoms period (304–439); and there is extensive proof of a very large number of Sogdians resident in Sui- and Tang-dynasty Chang'an.[25]

Chang'an had been a capital city as early as the Western Han dynasty (206 BC–AD 9), and it served as a capital sporadically during the Six Dynasties period.[26] The Sui-dynasty capital, called Daxing, was built on the edge of the old Han city of Chang'an; this new capital was renamed Chang'an in the Tang period.[27] During the Sui and Tang periods, luxury goods and necessities alike poured into the two principal commercial areas, the Eastern and Western Markets, which housed a number of individual bazaars where shops selling a particular type of merchandise—such as the Silk Bazaar—were located.[28]

Wine-dealers could be found in the Eastern and Western Markets and in the city's residential wards as well. Wine could be imbibed in a tavern, or in an inn where one also could find overnight lodging. Of particular interest here is the fact that inns with foreign connections offered the service of *hu ji*, or female drinking companions from Central and West Asia, whose exotic good looks made them especially popular with the customers.[29]

The identification of the Rosenkranz Chinese ceramic figure as an ethnic Sogdian can be verified by two recent archaeological findings. The first is the Northern Zhou-dynasty (557–581) tomb of An Jia (or An Qie), which was excavated in 2000 in the suburbs of Xi'an, Shaanxi.[30] An Jia (d. 579), a Sogdian, is an example of an important Westerner being buried in a Chinese city. He was a native of Guzang, one of the regions in China where people from the West resided during the era of the Southern Dynasties (420–589) and Northern Dynasties (386–581). An Jia was the *sabao*—an official post appointed by the Chinese government in the Northern Zhou period to administer the political and religious affairs of Central Asian residents[31]—of Tongzhou. He also was area commander-in-chief.

An Jia's tomb contained a sumptuous carved, painted, and gilded stone couch,[32] surrounded on three sides by an ornate stone screen with twelve illustrated panels showing Westerners in various settings. Many of these people have the beards, deep-set eyes, and high noses that are associated with the classic *hu ren*. In addition, a Zoroastrian ritual,[33] which is seen on the lunette above the entrance to the tomb, depicts two Zoroastrian priest-bird deities with archetypal *hu ren* physiognomies.[34] The features of the figure at the right (Figure 21), in particular, closely resemble those of the Rosenkranz ceramic wine-merchant. Inasmuch as the deceased, An Jia, was a Sogdian, one may presume that all of the classic *hu ren* depicted in his tomb were Sogdians as well; and, in turn, that the Rosenkranz figure also represents a Sogdian.[35]

The second archaeological finding supporting the identification of the Rosenkranz figure as an ethnic Sogdian is that of the Northern Zhou-period tomb of Shi Wirkak (buried 580), which was excavated in 2003 in the Xi'an area.[36] Like An Jia, Shi Wirkak was a Sogdian;[37] he was the *sabao* of the Liangzhou Prefecture. His tomb contained a carved, painted, and gilded stone sarcophagus with panels showing people in various settings. Included among these panels are two Zoroastrian priest-bird deities with archetypal *hu ren* facial features quite like those of the ones in the An Jia tomb.[38]

The Duan Boyang Head and the Croës and Musée Cernuschi Figures

Like those of the Rosenkranz figure, the heavy beards, bulging eyes, and prominent noses of the Duan Boyang surviving porcelaneous head (Figure 4), the Croës complete porcelaneous figure (Figures 5–6), and the earthenware figure in the Musée Cernuschi (Figure 8) epitomize the penchant for caricaturing non-Han people in mortuary sculptures during the Tang dynasty. Although their faces are different from that of the Rosenkranz Sogdian, these three virtually identical men represent ethnic Sogdians as well.

All three wear a very distinctive four-sided, high-crowned hat with a horizontal top; a shallow, upturned brim; and a vertical ornament on the front (Figure 13). The crown is fashioned of four slabs of clay (perhaps representing leather or felt), connected with heavily stitched seams that have been carefully indicated in clay. The entire brim and the vertical ornament have been painstakingly impressed with parallel wavy elements, possibly depicting fur.[39]

The high-crowned hat of these three ceramic tomb figures is remarkably similar to the hat worn by one particular Western figure who is repeated in several illustrated panels of the carved stone couch in An Jia's tomb (Figure 22). Not only are the heavily stitched seams indicated in many of the portrayals, but the crowns and brims frequently are both light- and dark-colored, possibly suggesting fabric and fur.[40] Inasmuch as the scenes depicted in Chinese tomb murals and mortuary furnishings commemorate the life of the deceased, this particular Westerner represents An Jia, a Sogdian, in several of his lifetime activities. Consequently, his hat—and, by extension, the three ceramic hats—would be one type of head-covering worn by Sogdians in the late sixth century.

Furthermore, the Croës porcelaneous figure grasps a large ewer. As evidenced by the attachment of the upper part of the handle to the rim of the vessel, the form of this ewer is based on Sogdian metalwork. The corresponding earthenware figure in the Musée Cernuschi holds a long, hollow object with a faceted, foliated rim, which might be a type of rhyton. The rhyton has been described as, "a quintessential Iranian drinking vessel that was in widespread use in Central Asia, particularly Sogdiana, where, for example, it is used by the Panjikent banqueters. From there, it apparently came to China by way of the Silk Road."[41]

The Turkic Eurasian Nomads

As discussed elsewhere in this study,[42] the bodies of the Rosenkranz ethnic Sogdian and the figure in the Royal Ontario Museum are remarkably similar (Figures 14–16). However, the heads are quite different. The slanting eyes, long curved nose, small pointed beard, and very long strands of braided hair mark the figure in the Royal Ontario (Figure 17) as one of the Turkic nomads of the Eurasian steppes.

The Turkic confederations of nomadic tribes inhabited the enormous stretch of deserts, grasslands, foothills, and mountains of Eurasia that extend eastward from the shores of the Black Sea into Inner Mongolia, broadly referred to as the Eurasian Steppes. This vast steppe land has been home to numerous non-Chinese hunting and herding, nomadic tribes for many centuries.[43] A reciprocal relationship between those nomadic tribes immediately to its north and China itself can be documented as early as the Shang dynasty (ca. 1600–ca. 1046 BC). It can be traced subsequently to commerce between the Xiongnu nomadic tribes and the Western Han dynasty; then to trade between the Xianbei nomads—who succeeded the Xiongnu—and China in the Eastern Han (AD 25–220) and Western Jin (265–316) periods.[44] It was the Toba branch of these Xianbei, who earlier had pushed into northern China, that eventually succeeded in uniting northern China and establishing their Northern Wei dynasty in 386.[45]

Although the precise origins of the later, Turkic, steppe people are uncertain, it is known that they became subjects of the Ruru (or Juan-juan) nomadic tribes in the mid-fifth century.[46] In 552, they overthrew the Ruru and established their Turkic Qaghanate (also referred to as the First Turkic Empire). During the next twenty-odd years, the principal Turkic Qaghan conquered all of the steppes north of China's borders. Meanwhile, his uncle took command of the western steppes and, in about 560, crushed the Hephthalites and seized Sogdiana, which had been under Hephthalite rule. By the end of the 570s, the Turks' authority extended over the Eurasian Steppes as far west as Crimea. With their great military power and their ability to control travel on the vital Steppe Route trading-network that

spanned the steppes,[47] these northern Turkic nomads were a force that would play a considerable role in the history of China and its interaction with the West.

China and the Turkic Eurasian Nomads

Relevant to this study is the Turks' notable presence in the Tang-dynasty capital city of Chang'an.[48] In its nascent years, China's Tang dynasty had been obliged to appease the Eastern Turks[49] with enormous bribes,[50] and even to repulse several Turkic incursions reaching as far into Chinese territory as Chang'an. However, in 630, the Eastern Turks fell to the Tang-dynasty Taizong emperor (r. 626–649). In the same year, at the request of the leaders of the Western Turkic tribal confederation, Taizong assumed the title of heavenly qaghan of the Turks, thus becoming the ruler of both China and the steppes.[51]

Taizong resettled the preponderance of the Eastern Turks into Chinese territories; at the same time, he moved many prominent families to Chang'an, where some of them served at the Tang court. Several Eastern Turkic tribal leaders became generals in the Tang army. For example, Ashina Zhong (buried 675), a Turkic chieftain who had affiliated with the Tang dynasty, was promoted to great general of the Right Imperial Guard and inherited the title of duke of Xue. After he died, he was buried in one of the attendant tombs that were part of the Imperial Cemetery adjacent to Zhaoling, the mausoleum of the Taizong emperor, in Liquan xian, near Chang'an.[52]

The Sogdians and the Turkic Eurasian Nomads

A close relationship between the Sogdians and the Turkic nomads had existed as early as about 560, when the Turks conquered the Hephtalites and seized Sogdiana, which became part of the Turkic Qaghanate.[53] Sogdian influence on the Turks was significant; indeed, Sogdian served as one of the Qaghanate's official languages.[54] Many Sogdians rose to positions of political prominence in the Qaghanate, and Sogdians became omnipresent in Turkic diplomatic and commercial activities.[55] Regarding the Turkic commercial activities, it has been said, "To the Chinese the Sogdians were the main merchants of the Türk steppe."[56]

China and the West: The Silk Road

The primary course of China's trade with the West during the Tang period was the main west-east trans-Asian overland caravan route that was part of a vast network of trade roads connecting India and the Mediterranean world to China, known in modern times as the Silk Road. The extent of this ancient international commercial thoroughfare, which was established in the first centuries BC, is impressive. For example, according to modern satellite imagery, the distance between the eastern Mediterranean port of Beirut and Luoyang is 4,280 miles, as the crow flies;[57] however, the turnings of the caravan paths would have made the actual distance traveled much longer. According to some estimates, it could have taken as long as a year for trade goods to be conveyed from one end of the Silk Road to the other. Generally, this merchandise was passed from one merchant to another many times along the way. Relay stations, where trade caravans could rest and merchants could buy or exchange goods, were located at key positions. It was principally over this Silk Road that enormous consignments of all types of Western material, both religious and secular, flowed into China from the West for many centuries.[58]

Endnotes

1. Victor Mair has cautioned, however, that the term *hu* is highly vexed, and has noted the controversies surrounding its usage and interpretation at various times and in various places. He cites the debate between Daniel Boucher and Yang Jidong on *hu* and *fan* as just one example of how there can be a falling out over the meaning of *hu*. (Victor Mair, personal correspondence, September 2011.)

2. For the definitive study of the status of all non-Han people in Tang-dynasty China, see Abramson 2008.

3. According to Albert Dien, by the Tang period, the term *hu* referred specifically to the Sogdians (Dien 2007, 425).

4. See "Deep Eyes and High Noses: The Barbarian Body" in Abramson 2008, 83–107, especially 87; Abramson 2003, 124.

5. Abramson 2008, 87; Abramson 2003, 129–130.

6. Luoyang 1973, pl. 9:3. For a brief biography, see Fong 1991, 150.

7. Zhongguo 1996, 58 (where he is described as a *hu ren*), color pl. 15:1, pl. 54:1–2, fig. 41:8.

8. Cixian 1984, pl. 4:2–3, fig. 4:5. For a brief biography, see Fong 1991, 149.

9. Henan 1972, color pl. 7. See also Quan Kuishan 2010, 171–174.

10. Kaogu 1959, pl. 10:9, fig. 2:1. For a brief biography, see Fong 1991, 154. Ceramics from this very important excavation have been exhibited and published frequently since 1959.

11. Kaogu 1959, pl. 9:1–3. See also "Early Northern Chinese Porcelaneous Tomb Figures" in Chapter 4, Ceramic Technology; "The Sui Dynasty" in Chapter 5, *Mingqi* Figures.

12. Liu Hongmiao, Sun Jiaoyun, and Zhang Xinyue 2005, 259, figs. 9–10. See also "Early Northern Chinese Porcelaneous Tomb Figures" in Chapter 4, Ceramic Technology; "The Sui Dynasty" in Chapter 5, *Mingqi* Figures.

13. For an excellent survey of Tang-dynasty mortuary figures of *hu ren* Westerners, see Qianling 2008.

14. For figures of wine-merchants, see "Western Wine-Merchant Figures" in Chapter 3, Western Wine-Merchant Figures and Wine.

15. Zhongguo 1980, 56–65, color pl. 2, pl. 85.

16. See "The Duan Boyang Figure" in Chapter 1, Attribution.

17. Sogdiana was not one unified country; rather, Sogdiana comprised a number of city-states that shared the Zarafshan River and adjacent river valleys. For a full investigation of Sogdian history, see "Homeland of the Sogdians, the Silk Road Traders: Samarkand and Sogdiana" in Hansen 2012, 113–139. See also "Legal and Political Structures" in de la Vaissière 2005, 167–169.

18. De la Vaissière 2005; Marshak 2001; Rong Xinjiang 2000; Azarpay et al. 1981. For a summary of Sogdian studies in China, see Cheng Yue 1996.

19. Mallory and Mair 2000, 255–256.

20. For the definitive study of the merchant Sogdians, see de la Vaissière 2005, where it is noted, "The apogee of Sogdian commerce lasted for about two and a half centuries, from the beginning of the 6th century to around the middle of the 8th century CE. It was preceded by a period of a century and a half of troubles and nomadic invasions, which are very poorly known and which profoundly changed the political and economic landscape of Central Asia, to the particular benefit of the Sogdians and their merchants. From the inclusion of Sogdiana in the empire of the Hephtalites at the beginning of the 6th century, and above all with the conquest of the whole of Central Asia by the first Türk Empire in the middle of the 6th century and the advance of Chinese armies a hundred years later, we note a clear predominance of Sogdian merchants over the great commercial land routes." (ibid., 95).

 A cache of sealed Sogdian letters discovered by Sir Aurel Stein in 1907 in a ruined Han-dynasty guard tower west of Dunhuang, Gansu Province, has provided a fascinating insight into Sogdian commerce. See "About the Ancient Letters" in de la Vaissière 2005, 43–70; Juliano and Lerner 2001a, 47–49, cat. no. 8.

21. Lerner 2001. For the nature of the Sogdian caravans, see "Mastering the Distance" in de la Vaissière 2005, 186–194; Arakawa Masaharu 2005.

22. Schafer 1963, 12, 281.

23. This subject is thoroughly examined in Rong Xinjiang 2000. For a study of Sogdians in Northwest China, see Luo Feng 2001. For literary references to the Sogdians in China, see "In China" in de la Vaissière 2005, 119–157.

24. Rong Xinjiang 2000, 151.

25. For the most recent, and definitive, study of Chang'an/Xi'an, see "The Cosmopolitan Terminus of the Silk Road: Historic Chang'an, Modern-day Xi'an" in Hansen 2012, 141–166. See also Rong Xinjiang 2000, 137–142. Merchants were the major component in the Sogdian community in Chang'an (ibid., 139). See also "The Capitals" in de la Vaissière 2005, 137–141.

26. See "Chang'an Before the Sui" in Xiong 2000, 7–30.

27 For a complete study of Chang'an during the Sui and Tang dynasties, see Xiong 2000.

28 See "The Marketplaces" in ibid., 165–194.

29 Xiong 2000, 181. The Tang poet, Li Bai (or Li Po), wrote of such places (de la Vaissière 2005, 140). Edward H. Schafer quoted Li Bai further, "a Western *houri* beckons with her white hand, inviting the stranger to intoxicate himself with a golden beaker." (Schafer 1963, 21).

30 Shaanxi 2001. See also Rong Xinjiang and Zhang Zhiqing 2004, 66–77; Shaanxi 2003; Yin Shenping, Xing Fulai, and Li Ming 2000.

31 For an in-depth study of the *sabao* office, see Luo Feng 2000.

32 For a discussion of other stone funerary couches and their relationship to the An Jia couch, see Juliano and Lerner 2001b. The authors have noted that these couches—together with a late sixth-century sarcophagus—are connected with each other and also are connected with Central Asia, specifically with Sogdiana.

33 Most Sogdians adhered to Zoroastrian beliefs. However, some Sogdians, although Zoroastrians, also adopted Buddhism. See de la Vaissière 2005, 2, 60, 77–79, 88–90, 141–143; Marshak 2001, 232.

34 Shaanxi 2001, figs. 8–9. See also Rong Xinjiang and Zhang Zhiqing 2004, 68–69; Shaanxi 2003, pls. 14–23. Buddhist *apsaras* playing musical instruments flank a Zoroastrian fire-altar here, demonstrating that Buddhist and Zoroastrian images could be intermixed at this time.

35 A caveat is in order here. Although many of the classic *hu ren* Westerners appearing in Chinese mortuary furnishings and ceramic tomb sculpture might depict Sogdians, it must be remembered that many of them are, in fact, *caricatures* of Sogdians, as seen through Chinese eyes. Remains of murals found in several Sogdian sites demonstrate that the Sogdians portrayed themselves in a very different way. See Grenet 2005, where it is noted, "[Sogdian murals] were centered on the king, not on Sogdiana itself, and they owed their original inspiration to Sasanian royal propaganda. The image of distant countries was derived not from the merchants' direct experience, but from borrowed pictorial models (China) or Greco-Roman stereotypes (India). The realities of trade are completely absent from the art of Sogdiana, and occupy a rather limited position in the Sogdian funerary reliefs of 6th-century China." (ibid., 440). See also Azarpay et al. 1981, particularly 150.

36 Xi'an 2004. See also Hansen 2012, 145–146; Rong Xinjiang and Zhang Zhiqing 2004, 59–65. See also three papers regarding this tomb in de la Vaissière and Trombert 2005: Yang Junkai, "Carvings on the Stone Outer Coffin of Lord Shi of the Northern Zhou," 21–45; Sun Fuxi, "Investigations on the Chinese Version of the Sino-Sogdian Bilingual Inscription of the Tomb of Lord Shi," 47–55; Yoshida Yutaka, "The Sogdian Version of the New Xi'an Inscription," 57–72.

37 Chinese-Sogdian bilingual inscriptions were carved into the tomb's stonework (Rong Xinjiang and Zhang Zhiqing 2004, 62).

38 Ibid., 64–65.

39 Similar hats—minus the vertical ornament—can be seen on four glazed-and-painted earthenware tomb figures, described in the archaeological report as *hu ren*, in the Tang-dynasty tomb of General Zhang Shigui (buried 657). This tomb, excavated in 1972, was a satellite burial to Zhaoling, the tumulus of the Tang-dynasty Taizong emperor (r. 626–649) in Liquan xian, near Xi'an, Shaanxi Province (Shaanxi and Zhaoling 1978, pl. 8:7–8. See also Qianling 2008, pl. p. 147). See also "Glazed-and-Painted Earthenware Figures" in Chapter 5, *Mingqi* Figures.

40 However, the vertical ornament is not indicated on any of these hats (Shaanxi 2003, pls. 32, 44, 46, 49, 54–57, 59, 63–64, 70–71).

41 Juliano and Lerner 2001b, 58.

42 See "The Rosenkranz and Royal Ontario Museum Figures" in Chapter 1, Attribution.

43 For a complete historical background of these many Eurasian nomadic tribal confederations, see Barfield 1989; Jagchid and Symons 1989.

Victor Mair used the term "north(west)ern peoples" to encompass early China's immediately adjacent northern nomadic neighbors and those peoples living to the northwest and west. It is his hypothesis that the histories of China and of the north(west)ern peoples are intimately interwoven, and that these north(west)ern peoples were key to the origins and development of the Chinese state (Mair 2004).

44 Valenstein 2007, 61–62; 72n12.

45 Mortuary figures of Xianbei nomads found in the Northern Wei-dynasty tomb of Sima Jinlong (d. 484) illustrate the Xianbei presence in northern China in the fifth century. For notes on this tomb, see "The Six Dynasties Period" in Chapter 5, *Mingqi* Figures.

46 For the definitive history of these Turkic nomads, see Golden 1992. See also "The Turco-Sogdian Milieux" in de la Vaissière 2005, 197–225; Sinor 1990; "The Turkish Empires and T'ang China" in Barfield 1989, 131–163; Jagchid and Symons 1989, 37–43, 69–71; Wechsler 1979a; Wechsler 1979b.

47 For notes on this northern trading-network, frequently referred to as the Steppe Route, or the Fur Route, see Valenstein 2007, 60–62.

48 For the relationship between these Turkic nomads and China's preceding Sui dynasty, see Xiong 2006, 207–214.

49 The Turkic Qaghanate, or First Turkic Empire, had been split between eastern and western factions about 583.

50 A "trade or raid" relationship had existed between the Chinese and the Eurasian nomads as early as the second century BC, when the Western Han dynasty established a policy of bribing the Xiongnu northern nomadic tribes in return for peace. The Turks, continuing this policy, had been able to obtain bribes—particularly large quantities of silk—from their Chinese neighbors during the Northern Zhou and Northern Qi eras of China's Six Dynasties period.

51 The second Tang emperor, Li Shimin (known by his posthumous Temple Title, Taizong) traced his ancestry not only to both Chinese aristocratic families and the non-Chinese ruling houses of the Northern Dynasties and Sui dynasty, but also to a very prominent Turkic tribe. It has been suggested that much of Taizong's behavior was "more in keeping with nomadic Turkish cultural traits than traditional Chinese ones." See "Taizong and Turkic Peoples" in Zhou Xiuqin 2009, 127–131. See also Abramson 2008, 34; "The Turkish Empires and T'ang China" in Barfield 1989, 131–163, especially 140–142.

52 This tomb was excavated in 1972 (Shaanxi and Liquan 1977). See also Li Xixing and Chen Zhiqian 1991, Bibliographies, n.p.; Fong 1991, 150. For the definitive study of the Zhaoling mausoleum, see Zhou Xiuqin 2009.

53 See "The Turco-Sogdian Milieux" in de la Vaissière 2005, 197–225.

54 For the role of the Sogdians in the Turkic Qaghanate, see Golden 1992, 144–145.

55 This Sogdian/Turkic relationship is depicted in a panel of the carved stone couch in An Jia's tomb, where the Sogdian, An Jia, is seen with men whose long hair and pointed beards identify them as Turkic nomads (Shaanxi 2003, pls. 54–56).

56 De la Vaissière 2005, 199.

57 I thank Anandaroop Roy for this information.

58 For an in-depth study of Silk Road history, see Hansen, 2012. See also Valenstein 2007, 69–71; Boulnois 2004; Whitfield 2004; Tucker 2003; Juliano and Lerner 2001c; Whitfield 1999. For a splendid pictorial tour of the Silk Road, see Norell and Leidy 2011.

Chapter 3

Western Wine-Merchant Figures and Wine

Western Wine-Merchant Figures

The Rosenkranz porcelaneous figure belongs to a small, cohesive group of early Tang-dynasty ceramic mortuary sculptures of classic *hu ren*, or non-Han Western people.[1] These kneeling figures may be porcelaneous ware (Figures 1–3, 5–7); glazed-and-painted earthenware (Figure 8); or earthenware with the distinctive Tang-dynasty *sancai* (three-color) glazes, such as a figure in the collection of the Royal Ontario Museum (Figure 23).[2] They all carry vessels that are attributes of the wine trade: a leather wineskin, a ewer, or a rhyton-type drinking vessel. Presumably, they represent either itinerant traders who brought wine from the West to the Chinese capital, or the ubiquitous urban figures, the non-Han tavern owners, known as *hu jiu* (barbarian wine-sellers).[3] As they did in life, these ceramic tomb attendants were meant to assuage the thirst of the deceased in the afterlife.

Wine

The Western wine-merchants in the Sui- and Tang-dynasty city of Chang'an could offer a variety of alcoholic beverages to their clientele.[4] Among these libations were fermented drinks made from cooked grains, primarily rice and millet, called *jiu* (traditionally translated as "wine," although these drinks are more closely related to modern beer or ale).[5]

The production of alcoholic drinks from fermented grains can be traced as far back as the Early Neolithic period (? to ca. twenty-first century BC) in China,[6] and it can be followed to the present day. It has been said, for example, that during the Western Han dynasty, the Chinese bribed the leaders of the Xiongnu northern nomadic tribes with around 200,000 liters of these grain-based "wines" annually to keep the Xiongnu from raiding the Chinese frontier.[7] Despite grape wine's short-lived popularity, which began during the Tang period,[8] alcoholic drinks made from grains have been the beverage of choice in China until modern times.

Wines made from fermented grapes, introduced to China from the West, became well known during the early Tang dynasty.[9] The history of grape wine in China has been succinctly summarized,

"we may conclude that *vinifera* [the domesticated Eurasian grape] and grape wine had been known in China since the Western Han. For centuries grape wine was brought to China from Central Asia as tribute or as an article of commerce. Grape was cultivated as a crop in limited areas in Kansu, and some wine was made from it by the use of traditional Chinese *ferment*. But the Chinese-made grape wines apparently could not compare in quality with those from Central Asia, and could not compete with the indigenous wines made from grain. Grape wine remained a rare, exotic drink. The wine industry received a boost in early Thang due to the introduction of the 'mare teat' grape from Kaochhang [the former Gaochang kingdom, now Turfan, in Xinjiang Province, which became a prefecture of the Tang Empire in 640] and a 'new fermentation process' which utilized the wild yeasts that occur naturally on the fruit. This variety apparently did quite well in the Thaiyüan [Taiyuan, Shanxi Province] region and the wine from it gained a significant degree of popularity."[10]

In addition to their well-known mercantile activities, the Sogdians engaged in other occupations during certain periods of their history. Pertinent to this study is the documentation of Sogdian settlers working as viticulturists in the fertile Turfan oasis mentioned in the preceding paragraph.[11] Inasmuch as the classic *hu ren* Westerners in the small group of ceramic tomb figures under discussion are all ethnic Sogdians, one might speculate that there is some allusion here to Sogdian grape wine.

Endnotes

1 See Chapter 1, Attribution; "*Hu Ren* Westerners" in Chapter 2, Sogdians ("*Hu Ren* Westerners") and Turkic Nomads.

2 Proctor 1979, fig. 12. This figure is 14⅜ in. (36.7 cm) high. See also Mahler 1959, 11, 195, pls. III:a–e.

3 See Abramson 2008, 92; Abramson 2003, 135. For wine-dealing in the Sui- and Tang-dynasty city of Chang'an, see Xiong 2000, 181–182, 189.

 The porcelaneous figure of a Turkic nomad in the Royal Ontario Museum seems to be an anomaly in the group of Tang tomb sculptures under discussion. The Turks did not engage in commerce directly; rather, they used Sogdian merchants as intermediaries between themselves and the non-nomadic world. Therefore, despite the fact that he is carrying a now-broken wineskin, this Turk may not depict a trader or a tavern owner. See "The Sogdians and the Turkic Eurasian Nomads" in Chapter 2, Sogdians ("*Hu Ren* Westerners") and Turkic Nomads.

4 Xiong 2000, 181. For an exhaustive and definitive study of alcoholic beverages in China, see H. T. Huang, "Fermentation and Evolution of Alcoholic Drinks" in Needham 2000, 149–291.

5 H. T. Huang in Needham 2000, 149–150.

6 Discoveries at the site of the Early Neolithic Jiahu Culture (ca. 7000–5600 BC), in Henan Province, have included what has been described as some of the country's oldest rice (McGovern 2009, 31). There also was evidence that "the world's earliest alcoholic beverage" was being produced by these Neolithic Jiahu people (ibid., 36–39). A variety of analyses of the residues of liquids found in some earthenware jars from the site disclosed that these liquids had been composed primarily of grapes or hawthorn fruit, honey, and rice (ibid., 37). Therefore, it is postulated that at one time, these jars had contained a mixed fermented beverage (ibid., 38). Of particular interest here is the inclusion of wild grapes as an ingredient in the Jiahu beverage, representing their earliest use for this purpose in the world (ibid., 39).

7 Barfield 1989, 47.

8 H. T. Huang has given two possible reasons for the relatively short-lived popularity of grape wine in China in Needham 2000, 242–243.

9 Ibid., 240–243. See also Schafer 1963, 141–145.

10 H. T. Huang in Needham 2000, 242. For viticulture in Shanxi Province, see Trombert 2005.

11 De la Vaissière 2005, 130–131; Trombert 2005, 267–268. For references to wine listed as an item of trade in the "Sogdian Ancient Letters," see de la Vaissière 2005, 51–52.

Chapter 4

Ceramic Technology

Ceramic Tomb Figures: Construction

The Rosenkranz and Royal Ontario Museum Figures

Some years ago, the Conservation Department of the Royal Ontario Museum examined the museum's porcelaneous figure of a Turkic nomad (Figures 9–11). Its findings suggested that

> "the body was made first, presumably in a mould, and that the neck and head, fashioned separately, were subsequently joined to the torso. Forearms and hands, the belt, ornaments and other attachments, including the long strands of hair, were also apparently made separately and subsequently applied to the figure while the clay was still wet."[1]

Recent examination of the Rosenkranz porcelaneous Sogdian figure (Figures 1–3) confirmed an identical method of manufacture: The Rosenkranz figure's head was made separately and then joined to the torso. This head—and presumably that of the Royal Ontario piece—probably was modeled freehand, rather than having been cast in a mold.

The arms, legs, and wineskin of the Rosenkranz wine-merchant also were made separately and attached to the body while the clay was still damp. This can be seen quite clearly in Figure 1, for example: the right leg did not adhere thoroughly to the body in the firing. (Inasmuch as the Rosenkranz and Royal Ontario figures' right legs are in different positions, there appears to have been a certain leeway as to how these components were attached.) Other features of the Rosenkranz figure, such as the epaulets, belt, and edging of the tunic, were executed in appliqué-relief. As seen in the edging of the tunic, some of these reliefs did not adhere totally to the body in the firing.[2] Secondary features in both figures, such as folds of garments, were incised into the clay while it was still damp.

The Croës and Musée Cernuschi Figures and the Duan Boyang Head

In turn, the Croës complete porcelaneous figure (Figures 5–7) and the matching glazed-and-painted earthenware figure in the Musée Cernuschi (Figure 8) essentially reflect the same method of manufacture. However, whereas the extraordinary heads of the Rosenkranz and Royal Ontario figures apparently were modeled by hand, the Croës, Cernuschi, and Duan Boyang heads are virtually identical and therefore must have been cast in a mold. The bodies of the Croës and Cernuschi figures, as well as the appliqué-relief epaulets at the shoulders and large dragon-roundels on the chests, also are basically

identical. This is evidence that all three pieces—whether porcelaneous ware or earthenware[3]—probably were made in the same kilns at about the same time.[4]

The Development of Northern Chinese Ceramic Wares[5]

The Clays of China

In the study of Chinese ceramics, it is essential to understand the nature of the materials used to create them. Indeed, as has been said, "The surface geology of China rather than the choices of potters thus played the decisive role in shaping the history of ceramics in China: the major clay types determined the emergence of low-fired and high-fired wares in both the north and the south."[6]

Early Northern Chinese Porcelaneous Wares

The natural porcelain clays of northern China are white-firing secondary kaolins.[7] These kaolinic clays were used to make white earthenwares in northern China as early as the Neolithic period, as evidenced by a small percentage of unglazed white pottery found in Longshan cultural sites (ca. 2400–2000 BC) in Shandong Province;[8] their use continued into the late Shang dynasty (ca. thirteenth–eleventh century BC).[9] For some unexplained reason, white wares do not seem to have been produced to any appreciable extent after the fall of the Shang; and they did not become an important factor in Chinese ceramics again until about the late sixth century.[10]

High-fired, glazed, white-bodied ceramics of various sorts have been included in the inventories of effects from several late sixth- and early seventh-century burials. Although not yet strictly conforming to the Western criteria of "true" porcelain,[11] these wares approach the Western standards, and might best be classified as porcelaneous wares.[12]

For example, tomb furnishings from the Northern Qi-dynasty tomb of Fan Cui (d. 575), near Anyang, Henan Province, included nine white-bodied wares with high-temperature glazes.[13] Among the almost 200 funerary objects discovered in the Sui-dynasty tomb of General Zhang Sheng (buried 595), in Anyang,[14] there were a considerable number of porcelaneous wares.[15] Another Sui-dynasty tomb, that of nine-year-old Li Jingxun (d. 608), was excavated in 1957 in the suburbs of modern Xi'an, Shaanxi Province. Because she was a member of two imperial families, her tomb was lavishly furnished. Notable among her ceramics are three highly developed porcelaneous vessels: a chicken-headed, dragon-handled ewer; a double-bodied, dragon-handled amphora; and a pilgrim bottle.[16] Yet another Sui-dynasty tomb, that of a high-ranking official, Li Yu (buried 605), was discovered in 2006 in the Xi'an suburbs. It contained eleven porcelaneous vessels, including a chicken-headed, dragon-handled ewer quite similar to the one found in the Li Jingxun tomb.[17] Some thirty porcelaneous objects were found in a tomb in Jiajingkou, about nineteen miles from the city of Gongyi (originally known as Gong xian), near Zhengzhou in Henan. Although there is no firm evidence to date this tomb, it has been attributed in the archaeological report to the Sui dynasty.[18]

Early Northern Chinese Porcelaneous Tomb Figures

Documentary examples of late sixth- and seventh-century porcelaneous figures are quite rare. The excavation of the Zhang Sheng tomb yielded ninety-five figures. Six of them have porcelaneous bodies with clear, uneven glazes that take on a light khaki green tone where they are thick. They comprise three quasi-identical pairs: two large, standing court officials (Figure 20);[19] two standing guardian warriors; and two *zhenmu shou* (tomb-quelling beasts). Various features of the court officials and the *zhenmu shou* figures have been defined in dark-brown pigment under the glaze.[20] These six sculptures are

of particular significance to this study because, at present, they represent the earliest-known Chinese porcelaneous tomb figures for which there is definite archaeological documentation.

Among the thirty porcelaneous objects found in the tomb in Jiajingkou, Henan, were twelve human figures and two *zhenmu shou*.[21] These figures are described as having porcelaneous bodies and white glazes that are tinged with green. Various features of five of the figures have been picked out in what is identified as red pigment under the glaze. The porcelaneous wares in this tomb have been attributed to the nearby Sui-dynasty Gongyi kilns.[22]

As of this writing, the excavation of the Tang-dynasty tomb of Duan Boyang, in the suburbs of Xi'an, uncovered the only published, firmly documented Tang-dynasty examples of tomb figures with porcelaneous bodies. One is the complete figure depicting a kneeling young man who is holding what presumably is a leather wineskin (Figure 12); only the damaged head of the second figure (Figure 4) remains. These two figures are datable to 661 or 667.[23]

Early Northern Chinese Lead-Glazed Earthenwares

The tradition of applying low-temperature glazes—which are fluxed with lead-oxide—to unfired clay bodies and firing these objects to earthenware hardness can be seen in northern Chinese mortuary ceramics of the early Western Han period. These Han lead glazes were used on low-firing, northern loessic-clay bodies that fired to a reddish orange color. They include an uncolored glaze that looks light reddish brown over the reddish clay; a coffee brown that takes its color from iron-oxide; and various greens that are derived from copper-oxide.[24] With very few exceptions,[25] lead-glazed mortuary ceramics did not appear again after the Han dynasty (206 BC–AD 220) until the second half of the sixth century.

The full-fledged use of low-fired lead glazes was renewed as early as the Northern Qi dynasty. However, these lead glazes now were applied to earthenware vessels with bodies that were made from the same white-firing secondary kaolinic clays as the contemporary northern high-fired porcelaneous wares.[26] Documentary examples include thirty-four white-bodied vessels with yellowish glazes that were found in 1973 in Shouyang xian, Shanxi Province, in the Northern Qi tomb of a high-ranking official, Kudi Huiluo (buried 562).[27] Tomb furniture from the Northern Qi tomb of a Xianbei nobleman, Lou Rui, prince of Dongan (buried 570), excavated in 1979–1981 in Taiyuan, Shanxi, included more than seventy earthenware objects with greenish yellow glazes.[28] Four earthenware flattened jars with amber-colored glazes were found along with the white-bodied porcelaneous wares in the Northern Qi tomb of Fan Cui (d. 575).[29]

In addition to these monochrome-glazed earthenwares, a white-bodied globular jar embellished with both yellow and green splashes was found in the Northern Qi-dynasty tomb of Lou Rui.[30] A long-necked bottle with a green-splashed whitish glaze was discovered in the Fan Cui tomb.[31] Two earthenware jars with green-splashed rice-yellow glazes were excavated in 1958 in Puyang, Henan; they were found in the Northern Qi tomb of a high-ranking official, Li Yun, who was buried in 576.[32] These ceramics typify the "new" northern Chinese earthenwares with polychrome lead glazes that eventually would develop into the classic eighth-century Tang *sancai* (three-color) wares.

Tang-Dynasty Glazed-and-Painted Earthenware Tomb Figures

A distinctive group of seventh-century Tang dynasty, white-bodied earthenware tomb figures is decorated with low-fired lead glazes,[33] as well as unfired pigments and occasional gilt touches painted over the glaze. Five documentary finds of such glazed-and-painted earthenware sculptures can be dated between 643 and 664,[34] suggesting a feasible attribution of "ca. 625–675" for this special family of figures. Their production apparently was discontinued toward the end of the seventh century.

Tang-Dynasty *Sancai* (Three-Color) Glazes

White-bodied earthenware mortuary vessels and figures alike were decorated with the splendid *sancai* (three-color) low-fired lead glazes during the Tang dynasty.[35] The uncolored glaze was used as a base, to which iron-oxide was added to produce a tone that ranges from straw through amber yellow to dark brown; copper-oxide gave rich grassy greens; and cobalt-oxide produced dark vibrant blues.[36] There also is an occasional turquoise blue glaze, which is derived from copper-oxide; as well as a creamy white color that actually is the uncolored glaze washed over the white body or a coating of white "slip," or liquid clay.

Among the earliest-documented *sancai*-glazed wares are three complete objects and some fragments found in 1972 in Fuping xian, Shaanxi, in the tomb of Li Feng (d. 674), fifteenth son of the Tang-dynasty Gaozu emperor.[37] Fabrication of *sancai* wares—one of the hallmarks of Tang China—was confined to the late seventh century and the first half of the eighth century. After a rebellion launched by General An Lushan in 755, which was disastrous to the country's economy, especially in the north, the use of sumptuous polychrome-glazed tomb wares declined sharply.

Kiln-Complexes

The great many parallels in the fabrication and ornamentation of the Rosenkranz, Royal Ontario Museum, Croës, and Musée Cernuschi figures and the Duan Boyang head indicate they all were made at the same northern Chinese kiln-complex and were more or less contemporary. Furthermore, the matching Croës and Cernuschi figures demonstrate that these kilns were manufacturing sophisticated tomb figures of both porcelaneous ware and glazed-and-painted earthenware in the seventh century.

As of this writing, these kilns have not been identified. Archaeologists have documented three Tang-dynasty kiln-complexes—Liquanfang, in the Tang-dynasty capital city of Chang'an (modern Xi'an), Shaanxi; Tongchuan, some 50 miles to the north of Xi'an; and the Gongyi (originally known as Gong xian) kiln-complexes near Zhengzhou, Henan, which are some 250 miles east of Xi'an—that were producing both porcelaneous wares and *sancai*-glazed earthenware figures. However, seventh-century glazed-and-painted earthenware figures were not represented in the excavated material, indicating that all of these finds probably are a little later than the coterie of figures featured here.

The Liquanfang Kilns

In 1999, during preparatory excavations for new construction, the ruins of four kilns were found in the Liquan district of Tang Chang'an.[38] A wide variety of defective material was excavated at these Liquanfang kilns, including the remains of many monochrome and *sancai* lead-glazed earthenware vessels; a few single-color and *sancai*-glazed small earthenware figurines; numerous unglazed earthenware vessels, figures, and separate heads; molds in which these figures and heads were cast; and several types of porcelaneous vessels. The high quality of sculpting seen in some of the earthenware figures indicates that this was an important kiln. Comparison of the Liquan ceramics with analogous documentary tomb material led the archaeologists to date these four kilns to 735–765. However, it is quite possible that some seventh-century kilns still lie under the multistoried buildings that surround the site.

The Tongchuan Kilns

The Tang-dynasty kiln-complex at Huangpuzhen, Tongchuan, also in Shaanxi, has been known since the late 1950s. This is the site of the Song-dynasty Yaozhou kilns that were the nucleus kilns in the production of the Song Northern Celadon wares; the Tang-dynasty stratum lay under the Song layer.[39] Many kinds of ceramics were excavated from the Tang stratum, including monochrome

and *sancai*-glazed earthenware vessels; large and small *sancai*-glazed figures; porcelaneous vessels, and a few small white-glazed figurines; celadon wares; objects with tea-dust, black, or suffused glazes; and painted wares. Pre-fired, or "biscuit-fired," material, and molds for casting vessels also were found. No mention of glazed-and-painted figures is made in the archaeological report, which states that the porcelaneous wares and *sancai*-glazed earthenwares were introduced during what is described as the prosperous Tang period (685–755).[40]

The Gongyi Kilns

Although the very important Gongyi (originally Gong xian) kiln-complexes near Zhengzhou, Henan, lay some 250 miles east of Tang Chang'an, transport of their wares to the capital by means of connecting rivers would not have been difficult. Indeed, fragments of Gongyi white wares have been excavated at the site of the Tang-dynasty Daming Palace in Xi'an, substantiating a provincial gazetteer's statement that during the Kaiyuan period (713–742), porcelain was sent as tribute to Chang'an.

Like the Tongchuan kilns, these kilns have been known since the late 1950s. Excavations in the vicinity of Gongyi city have unearthed the Baihe kilns, which concentrated on the production of white wares, and the Huangye kilns, in which Tang *sancai*-glazed wares were the major product.[41]

Thirty porcelaneous objects—including twelve human figures and two *zhenmu shou* (tomb-quelling beasts)—found in a tomb in Jiajingkou, Henan, have been attributed to the nearby Sui-dynasty Gongyi kilns.[42] If this is correct, these Gongyi kilns would seem to be the only identified kilns producing porcelaneous figures at that early period. Although the Rosenkranz porcelaneous piece and its associated figures are more sophisticated than the relatively simple Jiajingkou figures, it is not impossible that they were made slightly later at these Gongyi kilns.

The Gongyi Baihe Kilns

Excavations in the Gongyi Baihe area in 2005–2008 unearthed kiln-sites assigned by archaeologists to the Northern Wei dynasty and the Tang dynasty.[43] Ceramic production of the Northern Wei period mostly was confined to simple celadon vessels; there were a relatively few white-bodied cups and bowls with greenish white glazes found as well.[44] Porcelaneous wares, described as having white bodies and white glazes tinged with green—for the most part, simple vessels—apparently dominated production in the Tang period.[45] However, one excavated fragment is described as a piece of a horse.[46] Although it is scant, this would seem to be evidence that porcelaneous figures were being manufactured at these Gongyi Baihe kilns.[47] In addition to porcelaneous wares, these Tang Baihe kilns were producing black- and brown-glazed vessels; objects with monochrome and *sancai* lead glazes;[48] marbled wares; and wares with blue-painted decoration (e.g., Tang blue-and-white wares).

The Gongyi Huangye Kilns

The Gongyi Huangye kilns, situated less than two miles from the Baihe kilns, were major producers of an extensive array of *sancai*-glazed earthenware vessels and a quantity of *sancai*-glazed small figurines during the Tang dynasty.[49] Fragments of a few larger ceramic figures also have been found at these kilns.[50] Excavations at the kiln-site in 2003–2004 revealed four developmental stages, which the archaeologists dated to the Sui dynasty, the initial Tang, the flowering Tang to middle Tang, and the late Tang dynasty.[51] These excavations revealed that, in addition to *sancai* wares, the Huangye kilns were making white wares, which generally had a layer of slip between their white bodies and white glazes.[52] Wares with black, yellow, blue, or green monochrome glazes; marbled wares; and wares with blue-painted decoration have been found at these kilns as well.

Endnotes

1. Trubner 1962, 101. More recently, separate ceramic torsos, heads, and body-parts, as well as the molds in which they were cast, have been found, confirming this particular method of manufacture. For example, see the site of the Tang-dynasty Liquanfang kilns in modern Xi'an, Shaanxi Province (Shaanxi 2008, color pls. 46–50, 55–91, 95–106).

2. It is possible that some appliqués don't adhere to the body here because the technique of using porcelaneous clay for appliqué-relief work was new and still presented problems.

3. For the use of the same white-firing kaolinic clays in both northern Chinese porcelaneous wares and northern Chinese earthenwares, see Kerr and Wood in Needham 2004, 147–148.

4. The Croës figure is 20⅞ in. (53 cm) high and the Musée Cernuschi figure is 15¾ in. (40 cm) high. This difference in size cannot be attributed to shrinkage in the kiln (see Kerr and Wood in Needham 2004, 336–337); therefore, it can be assumed that they were cast in different-sized molds. The two sets of original molds could well have been carved by the same master artisan: evidence of virtually the same man's head being mold-cast in eight graduated sizes has been found in the Liquanfang kilns in Xi'an, Shaanxi Province (Shaanxi 2008, color pl. 123, top).

5. For the definitive study of Chinese ceramic technology, see Kerr and Wood in Needham 2004.

6. Sensabaugh 2010. Dr. Sensabaugh has offered a knowledgeable, easily understood explanation of the formation of these major clay types.

7. Kerr and Wood in Needham 2004, 146–147. For the formation of these kaolinic clays, see ibid., 122–123; Wood 1999, 91–92. See also Sensabaugh 2010.

8. Li Zhiyan 2010a, 74–78, fig. 1.46; Kerr and Wood in Needham 2004, 120–122; Wood 1999, 92, fig. p. 92; Valenstein 1989, 15–16, fig. 14.

9. Kerr and Wood in Needham 2004, 123–126. These unglazed Shang-dynasty white wares were fired to kiln temperatures of about 1050°C.–1200°C. If they had been fired to suitably higher temperatures, they would have become porcelaneous in nature (Wood 1999, 92–93, fig. p. 93). See also Quan Kuishan, Ding Pengbo, and Li Zhiyan 2010, 101–102, fig. 2.8; Valenstein 1989, 23–24, fig. 17.

10. For a recent survey of the development of white wares in China, see Shanghai 2005.

11. In the West, porcelain, strictly defined, is a high-fired ceramic that is white, translucent, hard, dense, impervious to liquid, and resonant when struck.

12. The clear glazes of these early porcelaneous wares generally have a greenish tone where they are thick.

13. Henan 1972, figs. 34–37. See also Quan Kuishan 2010, 191–193; Kerr and Wood in Needham 2004, 147.

14. Kaogu 1959. See also "Early Northern Chinese Porcelaneous Tomb Figures" in this chapter.

15. Some of these Zhang Sheng wares were reported as having celadon glazes in the original archaeological report. However, this statement was corrected in Feng Xianming et al. 1982, 182. For these and other Sui-dynasty porcelaneous wares, see Li Zhiyan 2010c, 210–214.

16. Zhongguo 1980, 3–28, pls. 17:4–5, 18:1.

17. Shaanxi 2009, figs. 27–31, 39:2–7. Only part of the dragon's head remains on the broken handle of the ewer from Li Yu's tomb (ibid., fig. 27).

18. Liu Hongmiao, Sun Jiaoyun, and Zhang Xinyue 2005. See notes about the Gongyi kilns, near Zhengzhou, Henan Province, under "Kiln-Complexes" in this chapter.

19. Kaogu 1959, pl. 9:1–3. These porcelaneous figures of court officials are 28⅛ in. (72 cm) high. See also "*Hu Ren* Westerners" in Chapter 2, Sogdians ("*Hu Ren* Westerners") and Turkic Nomads; "The Sui Dynasty" in Chapter 5, *Mingqi* Figures.

20. Kaogu 1959, pl. 9. The pupils of the eyes of the Rosenkranz and Royal Ontario Museum's figures, as well as of the Duan Boyang head, are punctuated with spots of dark brown.

21. Liu Hongmiao, Sun Jiaoyun, and Zhang Xinyue 2005, figs. 1–12, 29–30. These figures range from about 6⅛ to 12⅜ in. (15.5 to 31.5 cm) in height. See also "*Hu Ren* Westerners" in Chapter 2, Sogdians ("*Hu Ren* Westerners") and Turkic Nomads; "The Sui Dynasty" in Chapter 5, *Mingqi* Figures.

22. Liu Hongmiao, Sun Jiaoyun, and Zhang Xinyue 2005.

23. Shaanxi 1960, figs. 2–3. See also Chapter 1, Attribution.

24. Occasionally, both green and brown glazes can be found on the same object. For a detailed discussion of Han-dynasty lead-glazed earthenwares, see Wood 1999, 191–198. See also Li Zhiyan 2010b, 144–152.

25. For example, see the lead-glazed earthenware figures found in the Northern Wei-dynasty tomb of Sima Jinlong (d. 484) under "The Six Dynasties Period" in Chapter 5, *Mingqi* Figures. See also Quan Kuishan 2010, 169–170.

26 Kerr and Wood in Needham 2004, 147–148; Wood 1999, 200. See also Quan Kuishan 2010, 170.

27 Wang Kelin 1979, pls. 4:3,5, 6:1,4,6, figs. 12:2–3,5–6,8. For a brief biography, see Fong 1991, 155. See also Valenstein 2007, 78.

28 Shanxi and Taiyuan 1983, pl. 7, figs. 25–27, 29–33, 43. See also Feng Xianming 1983. For a brief biography, see Fong 1991, 149. See also Valenstein 2007, 77.

29 Henan 1972, color pl. 7.

30 Shanxi and Taiyuan 1983, fig. 28. See also Feng Xianming 1983.

31 Henan 1972, fig. 33.

32 Zhou Dao 1964, pl. 10:3–5. See also Quan Kuishan 2010, 174; Wood 1999, 200.

33 These particular glazes can be creamy, yellowish, or straw-toned.

34 See "Dating" in Chapter 1, Attribution; "Glazed-and-Painted Earthenware Figures" in Chapter 5, *Mingqi* Figures.

35 Li Zhiyan 2010c, 249–262; Wood 1999, 199–206. See also "*Sancai* (Three-Color) Glazed Earthenware Figures" in Chapter 5, *Mingqi* Figures. These *sancai*-glazed earthenwares generally had been pre-fired before the glazes were applied, and the objects subsequently were given a second, low-temperature firing (Kerr and Wood in Needham 2004, 501).

36 These colors often were used individually as monochrome glazes as well.

37 Shaanxi 1977, pl. 9:4–5. For a brief biography, see Fong 1991, 150.

38 This excavation has been fully reported and illustrated in Shaanxi 2008.

39 See Shaanxi 1992, which is a report of the 1984–1990 excavations of the Tang kilns.

40 Ibid., vol. 1, English Abstract, 536.

41 For Gongyi (Gong xian) clays and glazes, see Kerr and Wood in Needham 2004, 149–151, 546–547. Chemical analysis of the Gongyi (Gong xian) *sancai*-ware clays has shown that they were made from virtually the same materials as the local high-fired white wares (ibid., 149).

42 Liu Hongmiao, Sun Jiaoyun, and Zhang Xinyue 2005.

43 Henan 2009.

44 Ibid., figs. 1–20.

45 Ibid., figs. 93–132. A lid of one porcelaneous box is decorated with a simple underglaze-brown pattern (ibid., fig. 128). There is no mention of slip being used on these white wares.

46 This fragment is 6¾ in. (17 cm) long (ibid., fig. 131).

47 In addition, three other interesting porcelaneous fragments were found at the Baihe kiln-site. The first is the incomplete lid of a *boshanlu* (censer in the shape of Mount Bo) decorated with rows of elaborate, appliqué-relief foliated medallions, which some authorities identify as the Buddhist iconographic device, the flaming pearl (ibid., fig. 130). Similar, but less elaborate, appliqué foliated medallions ornament the lid of a porcelaneous *boshanlu* in The Museum Yamato Bunkakan, Nara. This censer, which has two full-relief dragons entwined around the base, is attributed by the museum to the Sui or Tang dynasty, seventh century (Yamato Bunkakan 1995, no. 103). Two rows of appliqué foliated medallions that correspond to the ones on the Yamato Bunkakan *boshanlu* appear on a large porcelaneous ewer offered for sale in 2008 by Gisèle Croës (Croës 2008a, 52–53).

Two fragments of porcelaneous dragon-heads in full relief also were found at the Baihe site (Henan 2009, figs. 132–133). Amphorae and ewers with dragon-head handles are well represented in Sui- and Tang-dynasty ceramics. Examples can be seen in the porcelaneous dragon-handled amphora and the ewer found in the Sui-dynasty tomb of Li Jingxun (d. 608) in modern Xi'an, Shaanxi Province (Zhongguo 1980, pl. 17:4–5). Again, the head of a dragon, which is biting the rim, is at the top of the handle of the Croës porcelaneous ewer (Croës 2008a, 52–53).

48 Including a fragment described as part of a *sancai*-glazed large horse (Henan 2009, fig. 201).

49 Henan 2000. For excellent recent surveys of Tang *sancai* wares excavated in Henan Province, see Zhengzhou 2006; Daikō 2004.

50 Two fragments of camel figures, one 16½ in. (42 cm) long, the other 12¼ in. (31 cm) long (Henan 2000, pl. 29:4–5). A broken mold for casting the back of a large human figure, which measures 15 in. (38 cm) from the top of the head to the waist, also was discovered (ibid., pl. 13:1).

51 Henan 2005.

52 Ibid., figs. 2–20.

Chapter 5

Mingqi Figures

Mingqi

All of the ceramic figures discussed here belong to a category of Chinese mortuary furnishings known as *mingqi*, which has been translated as "brilliant artifacts."[1] It has been explained, "In order to provide proper treatment and nourishment for [the spirit brilliance of the deceased] in this afterlife realm, therefore, *mingqi* are conceived as simulacra, extraordinary artifacts having the appearance and form of articles made for the living, but devoid of their use and function."[2]

Religious Beliefs

Considerable archaeological evidence has demonstrated that a concern with the afterworld appeared in China as early as the Neolithic period. It has been observed that excavated grave goods—stone and bone tools, weapons, and ornaments, as well as pottery vessels—that had been used in life

> "bear witness to a belief that life continued after death and that objects used during one's lifetime would continue to be employed beyond the grave . . . offerings of food and drink clearly indicate that the survivors were concerned about the welfare of the deceased and felt obligated to supply them with sustenance."[3]

It has been further observed that the late Shang-dynasty (ca. thirteenth–eleventh century BC) royal tombs at Anyang, Henan Province, provide evidence

> "that the Chinese believed the fortunes of state and the welfare of the living to be dependent on the good offices of the spirits of the rulers' ancestors. The Lord on High, Shang Di, ruled the universe and controlled the fate of all; that deity could only be reached through the spirits of the earlier kings who stood at his side where they might intercede on behalf of those still on earth. The impressive [royal Shang] interments, therefore, were meant to earn the gratitude and good services of the departed and to establish their credentials so that they might take their rightful position by Shang Di's side. This was a mutually beneficial arrangement: the living relied on their ancestral spirits to watch out for their welfare, while these spirits were able to occupy such exalted niches in the afterworld precisely because their descendants reigned as kings and maintained the proper sacrifices."[4]

Views of the other world changed during subsequent dynasties.[5] However, as has been noted,

> "the grave retained its significance during all periods; it was considered to be the meeting place of the two worlds, the portal to the afterlife.... The tomb, then was treated as a residence, a comfortable and familiar place where people could meet and communicate with the souls of their departed ancestors. The spirit might at times remain in such a tomb furnished with the accoutrements it had used in life, or when duties called, it could depart to the other world with the paraphernalia that would guarantee it being given due recognition."[6]

Therefore, the tomb needed to be supplied with the appropriate necessities and luxuries. For example, the late Shang royal tombs at Anyang were provided with real ritual bronze vessels, bronze weapons, and stone and jade carvings, as well as numerous human sacrificial victims.[7]

From Human Sacrificial Victims to Porcelaneous Figures of Western Merchants[8]

Paralleling the Chinese tradition of burying actual objects with the deceased, which can be traced back to the Neolithic period, is the tradition of burying non-functional representations of things known in life (that is, *mingqi*).[9] Although there were some exceptions, the majority of northern Chinese *mingqi* were made of soft, low-fired earthenware. These simulacra tomb artifacts can be life-size or in miniature. They range from ceramic imitations of things made of more expensive materials; to copies of ordinary articles such as dishes and jars; to models of buildings, vehicles, and animals; to an extensive array of human funerary sculptures (*yong*),[10] exemplified in this study by the extraordinary Rosenkranz figure and its associates.

Although a few earthenware human images have been found at Neolithic sites,[11] it is not certain if any of these ceramics were made specifically for burial. In addition to the numerous human sacrificial victims already mentioned, archaeological discoveries at middle and late Shang-dynasty sites have included a few ceramic human figures; but it is uncertain if they were intended to be substitutes for sacrificed people. Human replicas produced expressly for burial began to be an important category of mortuary furnishings during the late Spring and Autumn (770–481 BC) and early Warring States (481–221 BC) periods of the Eastern Zhou dynasty (770–256 BC). In northern China, a primarily ceramic tradition arose; in the south, the tradition mainly developed in wood. Although human sacrifices still were prevalent during the Eastern Zhou dynasty, they began to decline in number. This decline often has been linked to the growing use of ceramic or wooden tomb figures as surrogates for the actual victims. However, human sacrifice in burials did not entirely cease, as evidenced by a number of late Eastern Zhou tombs containing both human offerings and ceramic replicas.[12]

The First Emperor's *Mingqi*

In 1974, archaeologists working at the necropolis of China's First Emperor, Qin Shihuangdi (r. 221–210 BC), in the region of Lintong, near modern Xi'an, Shaanxi Province, discovered several elaborately constructed pits. These pits, which lay outside the two sets of walls surrounding the tomb-mound itself, contained an underground army of thousands of life-size, explicitly modeled earthenware[13] figures of soldiers and horses. All these figures originally had been painted with unfired, or "cold-painted," colored pigments;[14] however, most of these pigments have degraded. Some of the soldiers were outfitted with actual bronze weapons, and some horses drew real wooden chariots. Until they were found, anything remotely resembling these ceramic people and animals had been both unknown and unimaginable; they are the ultimate in *mingqi*.[15]

Excavations of the area adjacent to the tomb-mound have been ongoing since the original finds, and even more spectacular discoveries have been unearthed.[16] Among them are two highly realistic, half-life-size chariots, each with four horses and a driver, all cast from bronze. Each of these bronze sculptures was completely painted; the chariots and horses were further embellished with gold and silver.[17] These two chariot-ensembles were found in a pit directly connected to the First Emperor's burial chamber, and probably were for his personal use in the afterlife.

Apart from the two bronze charioteers, all of the enormous number of human sculptures excavated at the necropolis were made from the loessic clay of the region.[18] These earthenware *mingqi* figures generally were buried with other—non-ceramic—mortuary furnishings. As has been mentioned, some of the life-size earthenware soldiers in the underground army carried real bronze weapons and stood alongside actual wooden chariots. Elsewhere in the necropolis, fifteen ceramic musicians attended forty-six life-size bronze *mingqi* figures of water-birds in a subterranean water park.[19] Again, eleven full-size earthenware figures, representing stable administrators, were found with the actual skeletons of several hundred sacrificed horses in underground imperial stables. Fourteen other, but smaller, ceramic figures representing zookeepers, accompanied the remains of various sacrificed animals and birds in a subterranean zoo.[20] In addition, the ruins of eighty-seven sets of limestone armor and forty-three stone helmets were found in a storage pit between the two sets of walls surrounding the tomb-mound itself.[21] Like the two bronze *mingqi* chariot-ensembles and the bronze water-birds, this stone armor represents the use of materials besides clay in the fabrication of Chinese mortuary furnishings.

This is not to say that human sacrificial victims were not part of the Qin Shihuangdi funerary accouterments. A cemetery quite near the tomb-mound itself contained rows of tombs that probably belonged to the First Emperor's sonless consorts, who were compelled to follow him into death. In another area, seventeen large tombs held the remains of nobles who apparently had suffered an unnatural death.[22] It has been noted, "in [Qin Shihuangdi's] posthumous 'reality,' those most closely associated with the emperor—his consorts, courtiers, and relatives—were represented by human sacrifices, while those of lower status who performed more general governmental and military roles were represented by clay statues."[23]

The Han Dynasty

During the following Han dynasty,[24] the quantities and types of ceramic *mingqi* so greatly expanded that tomb furniture becomes a major element in the study of Chinese pottery. There are fundamentally two types of Han ceramic funerary wares. The first type consists of miniaturized earthenware replicas of almost everything known in life. These *mingqi* models created a microcosm of his or her former world for the deceased. People (including soldiers, attendants, servants, and entertainers), as well as possessions (such as chariots, farm buildings, wells, animals, houses, and all manner of household effects) were deposited to provide for the needs of the deceased in the afterlife. A second type of funerary ware, life-size earthenware vessels and utensils, generally used for ritual offerings of food, frequently has been found in Han tombs as well. Unlike the highly representational models of people and chattels, these large pieces cling to an inherited bronze tradition in form as well as in much of their ornamentation.

Archaeological discoveries have shown that some of the funerary traditions established during the Qin dynasty were maintained during the Western Han period.[25] For instance, an underground army of over 2,000 earthenware soldiers was excavated from pits accompanying the satellite tombs of two famous Han generals; these tombs were attached to the Changling mausoleum of the first Han emperor, Han Gaozu (r. 206–195 BC), at Yangjiawan, near Xi'an.[26] Bronze *mingqi* figurines also continued to be produced during the Western Han, as exemplified by a pair of bronze storytellers found in the rock-cut tomb of Liu Sheng, Prince Jing of Zhongshan (d. 113 BC), found in 1968 at Mancheng,

Hebei Province.[27] As seen in the stone figures of attendants and servants found in the Liu Sheng tomb, stone was employed as *mingqi* material during this period as well.[28]

There was a considerable decrease in the number of *mingqi* tomb sculptures during the Eastern Han period.[29] This decrease was due in part to the increasing popularity of the wall paintings, stone bas-reliefs, and molded clay tiles now being used to decorate the tomb chambers.[30] There was also a change in subject-matter, which departed from the Western Han interest in representations of the people who had served the deceased in life and shifted to a new emphasis on his or her material possessions.[31] Furthermore, by this time, noticeable variations in the distinctive styles of *mingqi* from different regions had become readily apparent.[32]

For the most part, both kinds of Han-dynasty northern Chinese earthenware *mingqi*—the miniaturized people and chattels, and the life-size ritual objects—either were left undecorated or were painted with unfired colored pigments over a preparatory layer of white slip, or liquid clay. In addition, a new kind of northern *mingqi*, glazed earthenware, was introduced during the early Western Han period. Here, green and/or brown low-fired, lead-fluxed glazes were used to embellish the clay bodies.[33] (Han green lead glazes were extremely vulnerable, and after long exposure to moisture in the tomb, most of them have degraded to a certain extent, acquiring a silvery iridescence.) With very few exceptions, however, these lead-glazed mortuary ceramics did not appear after the Han dynasty until the second half of the sixth century.

The Six Dynasties Period

Since the 1950s, archaeologists have excavated a profusion of northern Chinese ceramic tomb material datable to the Six Dynasties period,[34] which is more accurately referred to as "The Period of Disunion." This material has shown that during the turbulent years following the Han dynasty's fall, the use of *mingqi* declined considerably. When *mingqi* flourished again in the fifth century, the emphasis was on human figures, many of them military,[35] rather than on material possessions. Six Dynasties *mingqi* figures differed considerably in style, according to the date and area in which they were produced.[36] With a few exceptions, they were made of unglazed earthenware that frequently was slipped and then painted with unfired colored pigments.

Two developments in northern Chinese Six Dynasties *mingqi* figures are quite significant to this study. Both developments are documented by ceramics found in the Northern Wei-dynasty tomb of Sima Jinlong (d. 484), a high-ranking court official,[37] excavated in 1966 in Datong, Shanxi Province. This tomb contained almost 400 lead-glazed earthenware figures depicting a variety of human and animal subjects. On many of these figures, details, such as stripes in clothing, were picked out in colored pigments applied over the green or brown low-fired glazes.[38] This fifth-century innovation in the decoration of earthenware *mingqi* set the stage for the seventh-century glazed-and-painted earthenware figure in the Musée Cernuschi (Figure 8).[39]

Over one hundred figures from the Sima Jinlong tomb wear an outfit characteristic of the Xianbei Eurasian nomads,[40] a rounded, puffed-out headdress and a long, closed-collared overgarment with the sleeves hanging empty at the sides.[41] These fifth-century figures exemplify early mortuary figures portraying a non-Chinese people—in this case, the Eurasian nomads—and, as such, are precursors to the seventh-century figure of a Turkic Eurasian nomad in the Royal Ontario Museum (Figures 9–11).[42]

The Sui Dynasty[43]

As this study has shown, the human sacrificial victims originally placed in tombs to meet the needs of the dead in the afterlife eventually were replaced by surrogate *mingqi* figures of wood, bronze, stone, earthenware that was either left undecorated or painted with unfired colored pigments, and glazed

earthenware. By the late sixth century, a newly developed material, high-fired porcelaneous ware,[44] was added to the list of materials from which *mingqi* were fabricated.

Among the ninety-five ceramic figures in the Sui-dynasty tomb of General Zhang Sheng (buried 595) in Anyang, Henan,[45] six figures have porcelaneous bodies. These six figures are of particular importance to this study because, to date, they represent the earliest-known, firmly documented Chinese tomb figures made of what was then a very rare and expensive material. Thirty porcelaneous objects were found in a tomb in Jiajingkou, not far from the city of Gongyi (originally known as Gong xian), Henan. They include twelve human figures and two *zhenmu shou*, together with a variety of porcelaneous animals and vessels. Although there is no specific evidence to date this tomb, it has been attributed to the Sui dynasty.[46]

A quasi-identical pair of large,[47] standing court officials (Figure 20) was among the six porcelaneous figures in the Zhang Sheng tomb. One of these men (Figure 20, left) has a prominent nose, deep-set eyes, and heavy facial hair, the latter two features emphasized in dark brown. He exemplifies early mortuary figures caricaturing non-Chinese people with origins in the Western Regions, defined in this study as classic *hu ren* Westerners.[48] As such, this Zhang Sheng figure is a forerunner of the explicitly sculpted Rosenkranz seventh-century caricature of an ethnic Sogdian merchant (Figures 1–3), who is the embodiment of a classic *hu ren*.

The Tang Dynasty

During the Tang dynasty,[49] tomb figures included Chinese officials, court ladies and gentlemen, servants, musicians, and tomb guardians—as well as a liberal sprinkling of non-Chinese Westerners, including peddlers, grooms, camel drivers, and merchants.[50] The earthenware figures can be either undecorated; painted with unfired colored pigments; glazed and over-painted with unfired pigments; or covered with monochrome low-fired glazes that developed into the distinctive Tang-dynasty *sancai* (three-color) glazes.

Glazed-and-Painted Earthenware Figures

The white-bodied earthenware figure of a Sogdian wine-merchant in the Musée Cernuschi collection (Figure 8) is covered with a cream-tinged, low-fired lead glaze over which green, red, and black unfired pigments had been painted.[51] This figure represents a distinct group of seventh-century Tang dynasty, white-bodied earthenware tomb figures that are decorated with lead glazes, as well as with unfired pigments and occasional gilt touches painted over the glaze.[52]

Figures of this kind have been discovered in important tombs that were part of the numerous attendant burials in the Imperial Cemetery adjacent to Zhaoling, the mausoleum of the Tang-dynasty Taizong emperor (r. 626–649), in Liquan xian, near today's Xi'an.[53] One, the tomb of General Zhang Shigui (buried 657), was excavated in 1972.[54] Over 200 glazed-and-painted figures were found in this tomb.[55] Of particular interest here are eight figures—four men wearing four-sided, high-crowned hats[56] and four grooms—all of them depicting typical *hu ren*, or non-Han Westerners.[57] Another tomb, that of General Zheng Rentai (buried 664),[58] was excavated in 1971; it contained more than 400 glazed-and-painted figures.[59] Most notable among them are four large figures—two military officers[60] and two civil officials[61]—with particularly elaborate painted-and-gilded ornamentation. Still another attendant Zhaoling tomb, that of Princess Changle (d. 643), the fifth daughter of the Taizong emperor, was found in 1986; it contained over forty white-bodied, glazed-and-painted figures.[62]

Farther east, more than twenty glazed-and-painted, white-bodied figures were found during the 1998–2001 excavations of the tomb of Lady Li (buried 647) in Yanshi city, in the Luoyang area of Henan.[63] Among them was a figure of a *hu ren* Westerner wearing a four-sided, high-crowned hat[64] that is virtually identical to the hats worn by the four figures found in the Zhang Shigui tomb.[65] And

to the northeast, more than forty-five glazed-and-painted tomb figures were excavated in 1991 from the tomb of Cai Xuda (buried 643) in Chaoyang, Liaoning Province.[66]

Because of the very close correlation between the Musée Cernuschi complete glazed-and-painted earthenware figure and the porcelaneous head from the Duan Boyang tomb, which originally had been part of a whole figure (Figure 13, right and center), the Cernuschi figure probably was made about the same time as the head, which is datable to 661 or 667.[67] Inasmuch as the documented glazed-and-painted earthenware tomb figures all can be dated between 643 and 664, an attribution of "ca. 625–675" for this entire family of mortuary sculptures is suggested here. Comparable figures without documentation have been dated within the 625–675 time-frame as well.[68] Based on evidence from tomb excavations, it would appear that the production of glazed-and-painted earthenware figures was discontinued toward the end of the seventh century.

Sancai *(Three-Color) Glazed Earthenware Figures*

The Tang-dynasty glazed-and-painted earthenware figures were replaced by mortuary ceramics with the splendid *sancai* (three-color) low-fired lead glazes that embellish white-bodied earthenware tomb sculptures and vessels alike.[69] It has been explained,

> "The use of *sancai* wares in the north was subject to social restrictions, so the discovery of glazed figures in tombs is a clear indication of the status of both the ceramics and the deceased Earthenware figures formed part of the funerary procession and were displayed on carts. The number and size of the figures were determined by the rank of the deceased. Once the procession had arrived at the tomb, all the models were lined up outside When the coffin had been placed inside the burial chamber, the figures were moved into the tomb and placed in their proper positions."[70]

To date, the earliest-known, documented mortuary figures decorated in the full palette of *sancai* glazes appear to be the thirty-six figures found in the tomb of Qutu Jizha (buried 691), the thirteen-year-old grandson of Tang-dynasty General Qutu Tong, excavated in 1991 in Luoyang.[71] Production of these *sancai* wares—one of the hallmarks of Tang China—was restricted to the late seventh and first half of the eighth century. The use of sumptuous polychrome-glazed *mingqi* in burials declined sharply after the rebellion initiated by General An Lushan in 755, which proved disastrous to China's economy, particularly in the north.

Porcelaneous Figures

At present, the only published, firmly documented Tang-dynasty porcelaneous *mingqi* figures are the complete kneeling figure (Figure 12) and the surviving head from a damaged figure (Figure 4) from the Duan Boyang tomb in Xi'an, Shaanxi; they are datable to 661 or 667.[72] These two seventh-century finds have played an essential part in the investigation of the Rosenkranz figure, one of only six Tang-dynasty porcelaneous figures that have come to light during this research. The remaining three figures lack documentation. They are the Sogdian wine-merchant formerly in the collection of Gisèle Croës (Figures 5–7); the Turkic Eurasian nomad in the Royal Ontario Museum's collection (Figures 9–11); and the *hu ren* Westerner sold in London in 1978, and probably now in the Idemitsu collection.[73]

Endnotes

1 Cary Liu in Liu 2005a, in which he has given an in-depth examination of the concept of *mingqi*. See also Liu 2005b.

2 Liu 2005a, 210. He has elaborated further, "*mingqi* are conceived as items made for the afterlife, which lies between the realms of the entirely dead and entirely living. In order to maintain a balance, they are simulacra, having the appearance but not the capabilities of articles made for the living. Lifelike appearance connected these simulacra—vehicles, vessels, architectural replicas, musical instruments, and implements—to the realm of the living." (ibid., 214). See also "Spirit Articles" in Wu Hung 2010, 87–99.

3 Dien 1987, 1–2.

4 Ibid., 2.

5 For burial practices, Chinese religious beliefs, and the concept of two souls in subsequent periods, see ibid., 3–14. See also Wu Hung 2010.

6 Dien 1987, 11.

7 For Shang burial practices, see Thorp 1980, 51–57.

8 For the most part, this survey is limited to the ceramic surrogate figures of people (*yong*) made especially for placement in the elite tombs of northern China. For a full investigation of Chinese funerary figures, see "Tomb Figurines and the Medium of Representation" in Wu Hung 2010, 99–126. See also Bower 2002; Rawson 1992b; Los Angeles County Museum 1987; Kuwayama 1987; Bower 1982. For the development of tomb sculpture from the Neolithic period through the Han dynasty, see Wu Hung 2006. For the development and regional characteristics of tomb sculpture from the Han dynasty to the Qing dynasty (1644–1912), see Yang Hong 2006. For excavated tomb figures from the earliest periods though the Qing dynasty, see Cao Zhezhi and Sun Binggen 1996. For important archaeological finds from the Neolithic period through the Han dynasty, see Rawson 1996.

9 As Cary Liu has pointed out, in some reports of modern archaeological excavations, all objects buried in a tomb are considered to be *mingqi*; however, in other reports the term is limited to artifacts believed to have been made specifically for the deceased (Liu 2005a, 206). He also has noted that in assessing some excavated material, it often is difficult to distinguish objects made for the living from those made for the dead. Furthermore, there also may be objects originally intended for daily use or ritual use that have been converted for burial purposes (ibid., 209).

10 As Wu Hung has shown, "ancient Chinese tomb figurines rarely, if at all, represented named individuals; what they were made to signify were certain general 'roles' [e.g., attendants, military personnel, civil officials, musicians, entertainers or servants] considered essential to an ideal afterlife. This symbolic function of figurines was reinforced by props: furniture, instruments and other paraphernalia—real or surrogate objects which assisted these manufactured figures to fulfill their assigned roles." ("Role" in Wu Hung 2010, 102–106). He further observed, "a tomb figure does not have to be anatomically accurate to fulfill its symbolic role. Frequently, it was the human imagination that transformed a figurine—whether individually designed or mass-produced—into a surrogate." ("Verisimilitude" in ibid., 117–122).

11 Wu Hung 2006, 18–24.

12 Ibid., 41–47; Bower 2002, 24–26. For Zhou burial practices, see Thorp 1980, 57–62.

13 Frequently referred to as "terracotta." These figures are reported to have been fired at the relatively low temperature of 950°C.–1050°C. (Nickel 2007, 173).

14 Ibid., 173–174.

15 These early discoveries are detailed in Hearn 1980.

16 For recent, comprehensive reports of these discoveries, see Portal 2007; Wu Hung 2006, 49–67. See also Bower 2002, 27–29; Ledderose 2000, 51–73; Yang Xiaoneng 1999, 366–387.

17 See "Chariots" in Yates 2007, 37–40, figs. 23–24; Wu Hung 2006, 50–54, 57, figs. 1.28, 1.29.

18 Kerr and Wood in Needham 2004, 113–114, 424–427.

19 Duan Qingbo 2007, figs. 194–201.

20 Wu Hung 2006, 57–58.

21 Lin 2007.

22 Wu Hung 2006, 54–57.

23 Ibid., 67.

24 For a discussion of Han-dynasty *mingqi*, see Li Zhiyan 2010b, 138–144, 146–152; Bower 2002, 29–34; Rawson 1992b, 142–143; Kuwayama 1987, 68–74.

25 For Western Han-dynasty *mingqi*, see Wu Hung 2006, 72–81. For a special category of naked, armless, earthenware Western Han tomb figures, which originally were dressed in fabric clothing, see Wu Hung 2006, 76–79; Bower 2002, 30n43; Rawson 1996, cat. no. 79.

26 Wu Hung 2006, 73–74. Tomb figures representing military personnel, as well as domestic figures and animals, also have been found in satellite burials at the mausoleums of other Western Han-dynasty emperors (ibid., 74). See also Li Zhiyan 2010b, 138–140.

27 Rawson 1996, cat. no. 83, where it has been suggested that these foreign storytellers came from a country to the south of China. For the frequently published tombs of Liu Sheng and his consort, Dou Wan, see, in particular, "Mancheng Tomb 1 (of Liu Sheng) and Mancheng Tomb 2 (of Dou Wan)" in Wu Hung 2010, Index, 265. See also Yang Xiaoneng 1999, 388–409; Rawson 1996, 169–174.

28 Yang Xiaoneng 1999, 388–389; Rawson 1992b, 142–143, where it is observed that there was a hierarchy of burial goods within the tomb itself.

29 However, a rare set of nearly one hundred miniaturized bronze chariots and mounted guards is notable not only for its size, but for its continued extravagant use of bronze as *mingqi* material. This set of figures was excavated in 1969 from an Eastern Han tomb at Leitai, Wuwei, Gansu Province, and has since been published frequently (e.g., see Watt et al. 2004, cat. no. 2). For Eastern Han-dynasty *mingqi*, see Wu Hung 2006, 97–102.

30 E.g., Eastern Han stone bas-reliefs in the Wu Family Shrines, Shandong Province (Liu, Nylan, and Barbieri-Low 2005). See also molded clay tiles from Sichuan and Henan provinces (Rawson 1996, cat. nos. 101–105). See also Li Zhiyan 2010b, 131–133.

31 It has been said, "Western Han figurines, with their colorful representations of banquets and entertainment, were created to construct a comfortable domestic life, whereas Eastern Han tomb sculptures, with their barns, rice paddies, watchtowers, and pigpens, were designed to represent large estates." (Wu Hung 2006, 100).

32 E.g., a distinctive genre of earthenware figures from Sichuan Province (Bower 2002, 29–30; Rawson 1996, cat. nos. 109–114). See also all manner of Western and Eastern Han burial artifacts from Shandong Province (Beningson and Liu 2005).

33 See "Early Northern Chinese Lead-Glazed Earthenwares" in Chapter 4, Ceramic Technology.

34 For an exhaustive examination of Six Dynasties material culture, see Dien 2007. See, in particular, "Figurines" in Dien 2007, 218–229. For a comprehensive survey of Six Dynasties ceramic tomb sculpture in northern China, see Bower 2002, 34–36, 37–44. See also Quan Kuishan 2010, 163–168. For the development and regional characteristics of Six Dynasties tomb sculpture, see Yang Hong 2006, 106–118. For a pictorial survey of the evolution of *mingqi* from the Han through the Tang dynasties, see Watt et al. 2004. See also Kuwayama 1987, 74–81; Juliano 1975.

35 Dien 2007, 223.

36 E.g., the distinctive, rather crudely fashioned earthenware *mingqi* figures from northwest China, as exemplified by the over 200 figurines found in the Northern Zhou-dynasty tomb of Li Xian (d. 569) and his wife near Guyuan, Ningxia Hui Autonomous Region (Juliano and Lerner 2001a, cat. nos. 36:a,b–39:a-j).

37 For Sima Jinlong's political importance in the Northern Wei period, see Quan Kuishan 2010, 169–170; Fong 1991, 153, 183.

38 Shanxi and Shanxi 1972, pl. 14:3, figs. 14–20, 23–24. See also Los Angeles County Museum 1987, cat. nos. 46–52. For other artifacts from the Sima Jinlong tomb, see Watt et al. 2004, cat. nos. 69–71.

39 See "Glazed-and-Painted Earthenware Figures" in this chapter.

40 For these Xianbei Eurasian nomads, see "The Turkic Eurasian Nomads" in Chapter 2, Sogdians ("*Hu Ren* Westerners") and Turkic Nomads.

41 Shanxi and Shanxi 1972, figs. 15–17, 19–20. See also Dien 2007, fig. 9:14. Figures wearing similar Xianbei outfits have been found in a number of Northern Qi-dynasty tombs as well.

42 See "The Turkic Eurasian Nomads" in Chapter 2, Sogdians ("*Hu Ren* Westerners") and Turkic Nomads.

43 For a comprehensive survey of Sui-dynasty ceramic tomb sculpture in northern China, see Bower 2002, 44–48. See also Dien 2007, 227–228; Yang Hong 2006, 124–125.

44 See "Early Northern Chinese Porcelaneous Tomb Figures" in Chapter 4, Ceramic Technology.

45 Kaogu 1959. See also "Early Northern Chinese Porcelaneous Tomb Figures" in Chapter 4, Ceramic Technology.

46 Liu Hongmiao, Sun Jiaoyun, and Zhang Xinyue 2005. See also "Early Northern Chinese Porcelaneous Tomb Figures" in Chapter 4, Ceramic Technology.

47 These figures are 28 3/8 in. (72 cm) high (Kaogu 1959, pl. 9:1–3).

48 See "*Hu Ren* Westerners" in Chapter 2, Sogdians ("*Hu Ren* Westerners") and Turkic Nomads.

49 For a comprehensive survey of Tang-dynasty ceramic tomb sculpture in northern China, see Bower 2002, 44–47, 48–54. See also Yang Hong 2006, 127–139.

50 For an excellent survey of Tang-dynasty mortuary figures of *hu ren* Westerners, see Qianling 2008. See also "*Hu Ren* Westerners" in Chapter 2, Sogdians ("*Hu Ren* Westerners") and Turkic Nomads.

51 Only remnants of the green and red pigments are visible today.

52 These glazed-and-painted tomb figures depict both people and animals; their lead glazes can be creamy, yellowish, or straw-toned.

53 Many high officials and imperial relatives were successively buried near the Zhaoling mausoleum between 637 and 741 (Li Xixing and Chen Zhiqian 1991, Preface). For the definitive study of the Zhaoling mausoleum, see Zhou Xiuqin 2009.

54 Shaanxi and Zhaoling 1978. Zhang Shigui held the titles generalissimo of the Left Palace Guard and duke of the Guo State (Zhou Xiuqin 2009, 250). For a brief biography, see Fong 1991, 148–149; Li Xixing and Chen Zhiqian 1991, Biographies, n.p.

55 Many of these figures are illustrated in color in Li Xixing and Chen Zhiqian 1991.

56 One of these figures is illustrated in Qianling 2008, pl. p. 47. See also "The Duan Boyang Head and the Croës and Musée Cernuschi Figures" in Chapter 2, Sogdians ("*Hu Ren* Westerners") and Turkic Nomads, for these hats.

57 Shaanxi and Zhaoling 1978, pls. 8:7–8, 9:1–2.

58 Zheng Rentai held the titles generalissimo of the Right Courageous Guards and military commander of Liangzhou (Zhou Xiuqin 2009, 251). For a brief biography, see Fong 1991, 150; Li Xixing and Chen Zhiqian 1991, Biographies, n.p.

59 Shaanxi 1972. Many of these figures are illustrated in color in Li Xixing and Chen Zhiqian 1991.

60 These figures are 28⅛ in. (72 cm) high (Shaanxi 1972, color pl. 4, top left); they have been published many times since.

61 These figures are 27⅛ in. (69 cm) high (ibid., pl. 10:1).

62 Zhaoling 1988, pl. 1. See also Li Xixing and Chen Zhiqian 1991, Biographies, n.p., pl., p. 49.

63 Zhao Huijun and Guo Hongtao 2009. The imperial household spent much of its time in Luoyang from the middle of the seventh to the eighth century.

64 Ibid., color pl. 3:6.

65 It is interesting that virtually identical tomb figures have been discovered in two tombs, that of Lady Li (buried 647) in Yanshi, near Luoyang, Henan Province, and that of Zhang Shigui (buried 657), near Xi'an, Shaanxi Province, which is a decade later and approximately 235 miles away.

66 Liaoning and Chaoyang 1998, Tomb M1, 13–16, color pls., figs. 11–32.

67 See "The Duan Boyang Head and the Croës and Musée Cernuschi Figures" in Chapter 1, Attribution.

68 A number of glazed-and-painted earthenware tomb figurines were excavated from a tomb found in 1953 near Anyang, Henan Province. From the presence of a Tang-dynasty coin, this tomb can be dated to after 621 (Fontein and Wu Tung 1973, cat. nos. 84–86). Sixty-one white-bodied, glazed-and-painted earthenware figures were found in 1990 in a Tang tomb in Yanshi county, Henan Province. These Yanshi *mingqi* have been attributed to the early Tang period primarily on the basis of analogous figures from the Zhang Shigui (buried 657) tomb (Yanshi 1999).

69 For Tang *sancai* wares, see Li Zhiyan 2010c, 249–262; Wood 1999, 199–206. See also "Tang-Dynasty *Sancai* (Three-Color) Glazes" in Chapter 4, Ceramic Technology. See also Vainker, "Burial Wares" in Vainker 1991, 78–81.

70 Vainker 1991, 78.

71 Mengjin 1993, 52–66, figs. 4–10. For color illustrations, see also Daikō 2004, nos. 29–34.

72 Shaanxi 1960.

73 Sotheby Parke Bernet, London, Tuesday, December 12, 1978, lot 325; Idemitsu 1987, fig. 355.

Chapter 6

Ornamental Motifs

In addition to the virtually identical appliqué-relief belts with pendent ornamented implements worn by the Rosenkranz and Royal Ontario Museum porcelaneous sculptures (Figure 16)—as well as the much-simplified versions of these belts seen on the Croës and Musée Cernuschi ceramic figures[1]—six other major ornaments on these two sets of figures deserve attention.[2] The origins of most of these decorative motifs can be found in the West; and most of them also can be associated with Buddhism, which came to northern China from India by way of Central Asia. When these ornamental motifs reached China, the Chinese adopted them as their own and adapted them to their particular needs.

The Ornaments

Tasseled Streamers Issuing from an Ornamental Disk

It is surprising to find this ornament forming the enormous earrings on the Rosenkranz seventh-century porcelaneous figure (Figure 24). Until now, the motif had been found only on Northern Qi-dynasty ceramics and Northern Qi Buddhist sculpture.

For example, tasseled streamers issuing from an ornamental disk appear on a Northern Qi green-glazed earthenware jar in the collection of The Metropolitan Museum of Art;[3] on a Northern Qi celadon-glazed stoneware jar in the Metropolitan's collection[4] (Figure 25, left and center, respectively); as well as on another celadon jar in a Japanese private collection.[5] The same ornament also occurs on a jar found in 1982 in what has been described as a late Northern Dynasties tomb near Zibo city, Shandong Province.[6]

Similar tasseled streamers can be found on the elaborate headdresses of several Northern Qi stone Bodhisattvas found in 1996 at the site of the Longxing Buddhist Temple at Qingzhou, Shandong.[7] The motif also appears on the Northern Qi limestone head of a Bodhisattva (figure 25, right) from the southern Xiangtangshan Buddhist cave-temples in Handan, Hebei Province, now in the Metropolitan Museum's collection.[8]

Beaded streamers issuing from an ornamental disk also occur in the molded appliqué ornaments on unglazed earthenware vessels excavated at the site of the village of Yotkan, near the oasis town of Khotan, in what is now China's Xinjiang Uighur Autonomous Region.[9] In all probability, these earthenwares were produced between the second and sixth centuries.

The Motifs in the Epaulets: The Rosenkranz and Royal Ontario Museum Figures

There are two types of epaulets.[10] First, there are the identical epaulets connecting the Rosenkranz figure to its counterpart in the Royal Ontario Museum.[11] They consist of foliated panels containing a beaded cabochon over a design of confronting fish-like creatures within pearled roundels (Figure 26).

The Pearled Roundel

Study of the pearled roundel has shown that

> "[it] has been identified as a Sasanian astral and divine symbol. As such it is naturally associated with [the Goddess] Anahita, as is evident in the appropriation of the motif on decorative objects, notably on ewers, which are closely associated with her. Because of its divine connotations, Buddhist artists and the designers of funerary furnishings in China appropriated the design, and in their adoption of the pearled roundel, its spiritual symbolism was maintained."[12]

Also, "the pearled roundel with inscribed animals [such as the *makara* and the dragon discussed here] is apparently of western origin and its importation and adoption by Chinese artists brings along with the ornamental pattern its iconographical significance."[13]

The Makara

Although this image is not very clear, these confronting fish-like creatures probably depict the *makara* (also known as the *mojie*), a mythical sea monster with the head of a dragon and the body of a fish. It has been said of the *makara*,

> "It has its origins in Asian and Indian mythology, where it is considered to be a spirit of river water and the origin of life. The appearance of a *mojie* on a Chinese object shows the influence of Buddhism. *Mojie* appear in China around the end of the fourth century AD Many Buddhist examples of the *mojie* were known to Tang craftsmen and a number of Tang dynasty silver dishes have been found with it depicted on them."[14]

Confronting *makara* also can be found on Tang-dynasty earthenwares, such as a hexagonal, green-glazed plate excavated in 1992 in Luoyang, Henan Province.[15]

The Motifs in the Epaulets: The Croës and Musée Cernuschi Figures

The second type of epaulet connects the substantiating Croës and Musée Cernuschi figures. These identical epaulets depict a grimacing, frontal monster-mask surmounted by a five-petaled palmette (Figure 27).

The Monster-Mask

The monster-mask motif can be traced in Chinese art from the Tang dynasty back to as early as the Bronze Age.[16] For example, monster-masks can be found adorning the bags on a number of Tang earthenware tomb figures of camels.[17] They appear on a number of low- and high-fired sixth-century northern Chinese ceramic containers and jars.[18] A fragment of the base of a ceramic figure found during excavations of the late Northern Wei-dynasty (ca. 494–534) Buddhist Yongning Temple Pagoda in Luoyang, Henan, is decorated with several monster-masks.[19] In addition, this fragment has five-petaled palmettes like the ones over the monster-masks in these epaulets.

Monster-masks occasionally appear in Six Dynasties northern Chinese Buddhist cave-temples. Among the carvings at the late Northern Wei imperial Longmen caves near Luoyang, both single monster-masks (in the Putai and Huoshao caves) and a series of monster heads holding the ends of swags in their clenched teeth (in the Guyang cave) are visible on the lintels above some niches.[20] Prototypes of the Guyang mask-and-wreath motif, in turn, can be found on carved stone pillars in the Indian Buddhist cave-temples at Ajanta.

The monster-mask appears as a motif in the sculptural arts of the Eastern Han period. High-relief monster heads, along with three of the Animals of the Four Directions,[21] embellish a pair of stone funerary pillars in Quxian, Sichuan Province; these pillars probably were carved in the second century.[22] Discrete, elaborate relief monster-masks serving as supports for ring handles, or *pushou*, were an ornamental staple in all the crafts during the Han dynasty. For instance, among the Han painted or glazed earthenware *mingqi* containers, relief *pushou* are found on vessels that are replicas of contemporary bronzes. The ornamental *pushou* can be traced back to Eastern Zhou-dynasty bronzes and related ceramic bronze-casting material, as well as to bronze attachments on lacquer ware.[23] Ultimately, ferocious animal-like heads are found in Chinese art as early as the *taotie*-mask motif on early Western Zhou-dynasty (ca. 1046–771 BC) and Shang-dynasty bronzes.

Farther west, grotesque heads can be found among the molded appliqué embellishments on the unglazed earthenwares excavated at Yotkan.[24] It has been noted, "[the] grotesque head, which is found so frequently as an appliqué ornament on terra-cotta [earthenware] vases from Yotkan and other Khotan sites [was] directly derived from the model of the classical Gorgon's head."[25] The Greek Gorgon head, in turn, is reminiscent of the Egyptian deity Bes, an odd leonine god who is always depicted frontally, usually with a protruding tongue.

The Five-Petaled Palmette

Although it is depicted in many different ways, the conventional ornament known as a palmette has radiating petals that generally spring from a base resembling a calyx. The palmette seen here consists of oppositely set curving petals flanking a long lyrate center; these are linked at the base by two pairs of horizontal bands. It closely resembles a typical fleur-de-lis ornament, with the obvious difference that it has five, rather than three, closely juxtaposed petals.

The five-petaled palmette might be considered one of the hallmarks of sixth-century Chinese art. It appears on a number of high- and low-fired northern Chinese ceramics,[26] as well as on a marble sarcophagus, on a bronze belt ornament, and in a tomb wall painting.[27] Five-petaled palmettes comparable to the one here also appear in late Six Dynasties Buddhist art. Examples can be seen in northern Chinese Buddhist cave-temples, such as the ceilings of cave 2 at the Northern Qi-dynasty northern Xiangtangshan caves,[28] and the ceiling of cave 1 at the late Northern Wei-dynasty Gongxian caves near Luoyang, Henan.[29] Analogous five-petaled palmettes are in the headdresses of two painted clay sculptures of attendant Bodhisattvas, one in cave 427 and the other in cave 244, at Dunhuang, Gansu Province. Both of these caves have been attributed to the Sui dynasty.[30] A fragment of the base of a ceramic figure found during the excavations of the Yongning Temple Pagoda is decorated with several five-petaled palmettes as well as monster-masks.[31]

Five-petaled palmettes corresponding to the one here also appear among the molded appliqué ornaments on unglazed earthenware vessels excavated at Yotkan[32] and Akterek, in Xinjiang.[33] The palmette ornament also embellishes artifacts excavated from tombs belonging to the early Eurasian nomads. It was an ornamental staple on early Greek black-glazed and painted pottery, as well as on Greek jewelry and architecture. Ultimately, it can be traced back to ancient Egypt.[34]

The Dragon Set in a Pearled Roundel

The appliqué-relief pearl-bordered dragon-roundels on the chests of the Croës and Musée Cernuschi figures (Figure 28) provide an important connection to the Rosenkranz figure, where the same ornament also appears on the chest. (However, there are no dragon-roundel appliqués on the Royal Ontario Museum's figure of a Turkic nomad. Inasmuch as the native-Chinese dragon was not used as an ornamental motif by the northern nomadic peoples, this omission could well have been deliberate.[35])

Essentially, this three-clawed dragon is seen in profile. It has a large head with a long, thin nose. Its contorted posture probably was dictated by the circular frame. Its head, neck, upper torso, and two forelegs are in a naturalistic pose. The remainder of its long, curving body and one of the splayed hind legs arch over its head to parallel the shape of the pearled roundel; its other splayed hind leg is cramped to fit the available space.

Two analogous appliqué-relief dragon-roundels are on the bottoms of two bowls that were among a large number of green-splashed white wares salvaged from the remains of a ninth-century Arab ship found in 1998 off the coast of Belitung Island, near Sumatra (some 400 miles south of Singapore).[36] Chemical testing of eight samples of the Belitung green-splashed white wares suggests that the majority of these ceramics came from the kiln-complexes at Gongyi (formerly known as Gong xian), in Henan;[37] and a "probably Gong xian" attribution has been given to these two bowls.[38] Another analogous appliqué-relief dragon-roundel is on the bottom of a fragment of a Tang-dynasty green-and-yellow-glazed earthenware bowl now in the Metropolitan Museum's collection.[39] This fragment was among various types of Chinese ceramics found at the late ninth- to tenth-century site of Nishapur, in present-day Iran, by the museum's Iranian Expedition during its 1935–1940 excavations. A similar dragon-roundel also is on the bottom of a Tang-dynasty bowl with *sancai* (three-color) glazes excavated in 1983 in Yangzhou, Jiangsu Province.[40] Yet another very similar dragon appears on the base of a Tang-dynasty silver bowl with a grapevine pattern on the outside. This bowl—part of a large hoard of gold and silver objects found at Hejiacun, Xi'an, Shaanxi Province, in 1970—has been attributed to about the middle eighth century.[41]

Sculptural dragons appear in Tang-dynasty ceramics as well. A porcelaneous *boshanlu* (censer in the shape of Mount Bo) in the collection of The Museum Yamato Bunkakan, Nara, has two full-relief dragons entwined around the base. This censer is attributed by the museum to the Sui or Tang dynasty, seventh century.[42]

It is probable that these Tang-dynasty dragons originated as one of the Animals of the Four Directions, the Green Dragon of the East.[43] These Animals of the Four Directions—frequently referred to as *sishen* (Four Spirits), or *silingshou* (Four Divine Beasts)—are the Black Warrior of the North (a tortoise with a snake coiled around its body), Green Dragon of the East, Red Bird of the South, and White Tiger of the West. They have a long history in Chinese art. Two of the animals, the Green Dragon and the White Tiger, are painted on the doors to the Northern Qi-dynasty tomb of Lou Rui (buried 570) in Taiyuan, Shanxi Province.[44] The Animals of the Four Directions are on ornamental tiles excavated from a tomb in Dengxian, Henan, which has been attributed to the late fifth or the early sixth century.[45] The Green Dragon is one of three Animals of the Four Directions, along with a monster-mask, that embellish a pair of Eastern Han funerary pillars in Quxian, Sichuan. Pictorial representation of these four directional symbols apparently began as early as the Eastern Zhou period: drawings of the Green Dragon and the White Tiger appear on the lid of a lacquered-wood clothing chest found in 1978 in the tomb of Marquis Yi of Zeng (ca. 433 BC) in Suixian, Hubei Province (Zeng was a small state on the northern border of the state of Chu).[46]

It has been said of the Chinese dragon,

"By the Tang dynasty, two of the [four directional] creatures . . . had diminished in importance, leaving the field to the dragon and the Red Bird. This shift does not suggest that the representations of the creatures of the directions ceased to have a role, but rather that further symbolic qualities accrued to the dragon and bird. Both were especially auspicious creatures: the dragon represented the forces of both *yang* and creation, and controlled the heavens and the rain."[47]

The dragon motif, which is indigenous to China and was not part of the Buddhist iconography that had come to China from India, appears in Buddhist art of the Northern Dynasties period. The pedestals of several stone figural triads found at the site of the Longxing Buddhist Temple at Qingzhou, Shandong, have flying dragons—combined with lotuses, an auspicious object in the Buddhist faith—carved on either side of the figure of the Buddha.[48] These sculptures have been assigned to the Northern Wei and Eastern Wei periods.

China and the West: Cultural Influences

As this study has shown, the origins of most of the six major appliqué-relief ornaments on the Rosenkranz, Royal Ontario Museum, Croës, and Musée Cernuschi ceramic figures can be found in the West.

Streamers issuing from an ornamental disk have been found at the site of Yotkan, near the oasis town of Khotan. The *makara* had its origins in Asian and Indian mythology; and the pearled roundel has been identified as an astral and divine symbol in Sasanian Persia. Two other motifs, the monster-mask and the five-petaled palmette, appear in the arts of ancient Egypt and/or Greece and eventually found their way to China by one of several different routes.[49]

At the same time, most of these ornamental elements can be directly or indirectly associated with the Buddhist religion, which originated in India and came to northern China from India by way of Central Asia.[50] Buddhism most likely reached China during the Eastern Han dynasty, probably in the first century AD. It gained extensive popularity in the succeeding Six Dynasties period, and was firmly established in Tang-dynasty China. As it became widespread, Buddhism, with its new system of beliefs and iconography,[51] was to leave its indelible imprint on virtually every facet of Chinese life.

Tasseled streamers with a disk can be seen on several Northern Qi-dynasty stone Bodhisattvas. The appearance of a *makara* on a Chinese object shows the influence of Buddhism; and the pearled roundel was appropriated by Buddhist artists and the designers of funerary furnishings in China. The monster-mask and five-petaled palmette both appear in Six Dynasties northern Chinese Buddhist cave-temples. In addition, the native-Chinese dragon is seen on stone figures from the site of the Northern Dynasties Longxing Buddhist Temple at Qingzhou.

The ornamental motifs derived from Buddhism could have been transmitted to China with the expansion of Buddhism, by way of diplomatic embassies, or through trade (these are closely related and sometimes inseparable). According to a widely accepted theory, the Buddhist iconography and style prevalent in Chinese Six Dynasties art most likely were transported from the West by means of small and easily portable images, paintings, and iconographic pattern books that might have been the property of pilgrims returning to China from India or among the effects of Buddhist translators or missionaries.[52]

However they were conveyed, all of these Western motifs probably would have followed much the same itinerary on their journey. Their primary course was the main west-east trans-Asian overland caravan route that was part of a vast network of trade roads connecting India and the Mediterranean world to China, known in modern times as the Silk Road.[53] A few motifs also followed a northern trading-network that spanned the steppes, often referred to as the Steppe Route or the Fur Route.[54]

Endnotes

1. See "Analogous Figures" in Chapter 1, Attribution.

2. Much of this chapter has been adapted from Valenstein 2007.

3. Metropolitan Museum accession no. 1996.15 (Valenstein 2007, fig. 16; Valenstein 2003–2004, figs. 10, 12; Valenstein 1997–1998, fig. 1).

4. Metropolitan Museum accession no. 2002.268 (Valenstein 2007, fig. 19; Valenstein 2003–2004, figs. 14, 16).

5. Kamei Meitoku 1998–1999, figs. 14:a,c.

6. The glaze on this jar has been called a "celadon glaze" in some publications and a "low-fired lead glaze" in others (Zibo and Zichuan 1984, figs. 2–3. See also Valenstein 2007, fig. 9; Valenstein 1997–1998, fig. 7).

7. E.g., Hong Kong and Qingzhou 2001, cat. nos. 66–68.

8. Metropolitan Museum accession no. 14.50 (Valenstein 2007, fig. 21; Zhang Lintang and Sun Di 2004, color pl. 6, figs. 18–19 on p. 193).

9. E.g., Metropolitan Museum accession no. 30.32.55 (Valenstein 2007, fig. 22; Valenstein 2003–2004, fig. 13, right). Examples now in the State Hermitage Museum, Saint Petersburg, are illustrated in Dyakonova and Sorokin 1960, pl. 43.

10. As far as can be determined, epaulets like these do not appear on the eighth-century earthenware mortuary sculptures of kneeling Western wine-merchants with *sancai* (three-color) lead glazes.

11. These epaulets can be seen in Royal Ontario 1992, pl., p. 260.

12. Karetzky 2001, 367. For an in-depth examination of the pearled roundel, see ibid., 348–367. For pearled roundels containing paired confronting hybrid creatures [e.g., the *makara*], see ibid., 360–361. For inhabited pearled roundels in Buddhist art, see ibid., 362, 364, 366.

13. Karetzky 2001, 363.

14. Michaelson 1999, 98–99, cat. no 59.

15. Zhengzhou 2006, pl. 155.

16. For a study of the monster-mask motif, see Valenstein 2007, 31–35. For the apotropaic role of monster-masks, see ibid., 31–32; Knauer 1998, 126–129.

17. See "Demonic Masks" in Knauer 1998, 78–95, pls. 50, 52, 57–61, 64, 66; Valenstein 1992, pl. 22 (Metropolitan Museum accession no. 1991.253.13).

18. Valenstein 2007, figs. 1–2, 5, 7, 12, 15, 41.

19. Zhongguo 1996, color pl. 31:1, pl. 109:2, fig. 89:1. See also Valenstein 2007, fig. 43.

20. Longmen and Beijing 1991. The single monster-masks in the Putai and Huoshao caves are illustrated in vol. 1, pls. 78, 184. The multiple masks in the Guyang cave are in vol. 1, pls. 147, 162–163, 170, 173–175, 177. See also Valenstein 2007, fig. 44. For other examples of monster-masks in Six Dynasties northern Chinese Buddhist cave-temples and Six Dynasties Buddhist sculptural art, see ibid., 33–34.

21. These are the White Tiger of the West, Green Dragon of the East, and Red Bird of the South, which are placed in their appropriate directions.

22. Laurence Sickman in Sickman and Soper 1968, pl. 14:a,b.

23. For examples, see Valenstein 2007, 34–35.

24. Valenstein 2007, fig. 42; Dyakonova and Sorokin 1960, pl. 19, upper left and right.

25. Stein 1921, vol. 3, 1193.

26. Valenstein 2007, figs. 3, 5–6, 11, 13, 55, 57–58.

27. Ibid., figs. 59–61.

28. Valenstein 2007, fig. 62; Zhang Lintang and Sun Di 2004, pl., p. 109; Zhongguo Meishu Quanji 1989, pls. 110, 115.

29. Valenstein 2007, fig. 63; Henan 1983, pls. 93–94, fig. 14.

30. Akiyama Terukazu and Matsubara Saburo 1969, pls. 28–29, 37–38.

31. Zhongguo 1996, color pl. 31:1, pl. 109:2, fig. 89:1. See also Valenstein 2007, fig. 43.

32. Valenstein 2007, fig. 64; Stein 1921, vol. 1, 93–127, vol. 4, pl. 3 (two fragments, lower-left corner).

33. Stein 1921, vol. 1, 133–153, vol. 4, pl. 4 (A.T.040).

34. Valenstein 2007, 45–46.

35. It has been observed, "To nomadic peoples inhabiting the borders of China, the dragon motif was alien; their beliefs did not necessarily reserve a special place for the *long* [dragon]." (Rawson 1984, 94).

36. Krahl et al. 2010, figs. 50, 116, cat. nos. 218–219.

37. See "The Gongyi Kilns" in Chapter 4, Ceramic Technology.

38. Krahl et al. 2010, cat. nos. 218–219.

39. Metropolitan Museum accession no. 38.40.247 (Wilkinson 1973, 258:13).

40. Zhengzhou 2006, pl. 186.

41 This dragon is shown in Watt et al. 2004, cat. no. 211.

42 Yamato Bunkakan 1995, no. 103.

43 For accounts of these four directional symbols, see Rawson 1984, 90–93; Juliano 1980, 35–43. For the Green Dragon of the East, see Juliano 1980, 42–43. For the dragon in Chinese art, see Rawson 1984, 93–99.

44 Shanxi and Taiyuan 1983, pl. 2:1. See also Valenstein 2007, fig. 35. A monster-mask is painted on the lunette above these doors.

45 Henan 1958, figs. 19, 36–37, 39. See also Juliano 1980, figs. 14, 16–17, 22.

46 Hubei 1989, vol. 1, fig. 216, vol. 2, color pl. 13, pl. 121.

47 Rawson 1984, 95.

48 Hong Kong and Qingzhou 2001, pls. 2–3, 5–8, 10–12.

49 See "From Greece to India to Khotan" in Valenstein 2007, 65–66.

50 See "Buddhism from India to Khotan" in ibid., 68.

51 See "Buddhism" in ibid., 66–68.

52 Soper 1960, 56. See also Valenstein 2007, 68–69.

53 See "China and the West: the Silk Road" in Chapter 2, Sogdians ("*Hu Ren* Westerners") and Turkic Nomads.

54 For notes on this northern trading-network, see Valenstein 2007, 60–62.

Chapter 7

Observations

First. The most remarkable feature of the Rosenkranz figure (Figures 1–3) is its porcelaneous body. As opposed to the literally thousands of known Tang-dynasty earthenware tomb sculptures, only six Tang porcelaneous figures have been located during this investigation. This paucity of porcelaneous tomb figures is not surprising. Although high-fired white wares had been developed in China in the sixth century, porcelaneous ceramics still would have been a relatively rare and expensive commodity in the seventh. Therefore, the use of such valuable material to create a fifteen-inch-high ceramic sculpture was extravagant indeed. Furthermore, the brilliant modeling of the figure's head and the exceptional appliqué-relief ornamentation indicate the employment of a ceramic workshop's master craftsmen, which would have added considerably to the figure's cost. Inasmuch as the quality and quantity of mortuary furnishings in a Tang tomb were dictated by the status of the deceased, this splendid porcelaneous figure must have been ordered for the tomb of a person of significant stature.

Second. This figure is one of a small group of Tang-dynasty ceramic tomb figures depicting kneeling Sogdian wine-merchants. These *mingqi* figures can be porcelaneous ware (Figures 1–3, 5–7), glazed-and-painted earthenware (Figure 8), or *sancai*-glazed earthenware (Figure 23). It is theorized here that they all represent either itinerant Sogdian wine-merchants who brought wine to the Tang capital of Chang'an, or the *hu ren* Western merchants who ran the famous wineshops in that city.

However, the tomb figure that is most closely related to the Rosenkranz piece is not a Sogdian, but the Turkic nomad in the Royal Ontario Museum's collection (Figures 9–11). These two figures are fabricated of the same porcelaneous material and are almost precisely the same size. Both heads are superbly hand-modeled, with great attention to minute detail (Figures 14–16). They have the same elaborate epaulets on their tunics, and are wearing virtually identical appliqué-relief Turkic belts with ornamented pendants in the back (Figure 16). The Turk is holding a now-broken wineskin that most likely had matched the one clasped by the Sogdian. It is proposed here that these two remarkably similar *mingqi* were crafted in the same workshop at the same time.

In a number of Chinese archaeological reports, the inventory of ceramic figures excavated from a tomb frequently has included several quasi-identical pairs of sculptures. For instance, three outstanding porcelaneous examples of such quasi-identical pairs—two large standing court officials (Figure 20), two standing guardian warriors, and two *zhenmu shou* (tomb-quelling beasts)—were found among ninety-five ceramic figures in the Sui-dynasty tomb of General Zhang Sheng (buried 595) in Anyang, Henan Province.

Historically, a close relationship between the Sogdians and the Turkic nomads had existed as early as about 560, when the Turks crushed the Hephtalites and seized Sogdiana, which became part of the Turkic Qaghanate. Therefore, it would have been accurate to depict a Sogdian with a Turk in late sixth- and seventh-century mortuary figures.

In view of this evidence, it seems reasonable to conclude that the Rosenkranz Sogdian wine-merchant and the Royal Ontario Turkic nomad are a quasi-identical pair that became separated.

Third. The Turkic nomad's slanting eyes, long curved nose, small pointed beard, and very long strands of braided hair are depicted with great accuracy. Furthermore, no dragon-roundel appliqué appears on this figure, as it does on the Rosenkranz, Croës, and Musée Cernuschi Western wine-merchant figures. Inasmuch as the native-Chinese dragon used as an ornamental motif was alien to the northern nomadic people, this omission could well have been deliberate. The careful attention to details in portraying this Turk suggests that the figure was intended for the tomb of someone associated with the Turkic nomadic culture.

Fourth. *Mingqi* figures representing foreigners were not entirely new in seventh-century Tang China. By the late fifth century, ceramic depictions of non-Chinese Eurasian nomads were included in Chinese tombs. Notably, more than one hundred earthenware figures found in the Northern Wei-dynasty tomb of Sima Jinlong (d. 484) in Datong, Shanxi Province, wear an outfit characteristic of the Xianbei Eurasian nomads.

Western peoples appeared in Chinese mortuary arts by the early sixth century. Two standing figures of hirsute men with very prominent proboscises were discovered in Luoyang, Henan, in the Northern Wei-dynasty tomb of Yuan Zhao (d. 528). There was a pair of lifelike earthenware *hu ren* Westerners in the Sui-dynasty Zhang Sheng tomb (Figure 19). One of the porcelaneous standing court officials from the Zhang Sheng tomb (Figure 20, left) has a prominent nose, deep-set eyes, and heavy facial hair. This Zhang Sheng official—like the later Rosenkranz Sogdian wine-merchant—exemplifies the *mingqi* figures caricaturing non-Chinese people with origins in the Western Regions, defined here as classic *hu ren* non-Chinese Westerners.

Fifth. The Rosenkranz, Royal Ontario Museum, Croës, and Musée Cernuschi ceramic tomb figures illustrate the longtime impact of foreign influences on Chinese culture that is characteristic of northern Chinese art. Most of the major appliqué-relief ornamental motifs on these four figures can be found in the arts of the West; they reached northern China by one of several different routes. At the same time, the origins of most of these motifs can be directly or indirectly associated with the Buddhist religion, which originated in India and came to northern China from India by way of Central Asia. By the sixth century, these foreign decorative motifs had been combined with the native-Chinese motifs to form a new Chinese ornamental idiom, which became the basis of the arts in a very cosmopolitan seventh-century Tang China.

Sixth. These four intact ceramic tomb figures and the figure implied by the surviving Duan Boyang head, per se, demonstrate the cosmopolitanism of China in the Tang period. Ceramic mortuary furnishings were crafted by Chinese artisans and were fired in Chinese kilns. They were predicated on Chinese concepts of the afterlife and were destined for Chinese tombs. However, these ceramic *mingqi* sculptures do not represent Han Chinese. Instead, they depict the ethnic Sogdians ("*hu ren* Westerners") and the Turkic Eurasian nomads who had become an integral part of the Chinese scene.

Figures

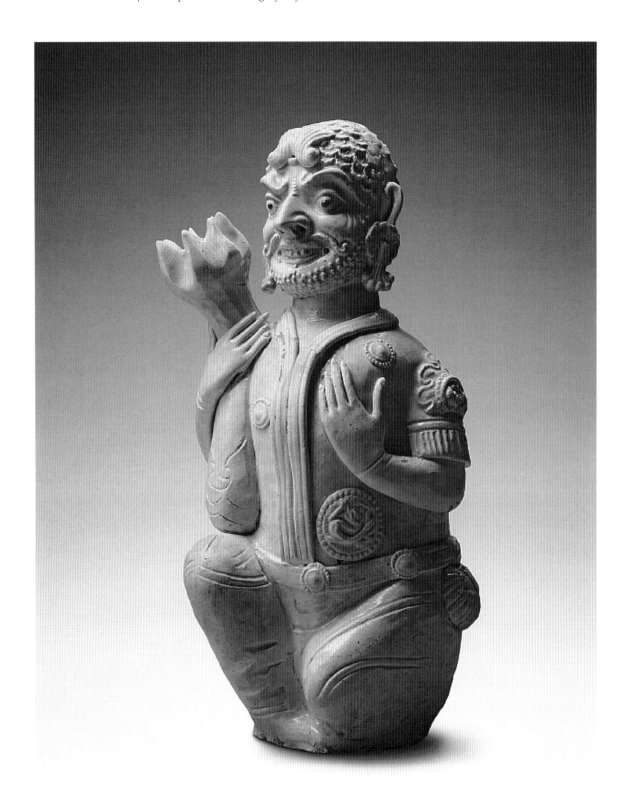

Figure 1 Figure of a Sogdian wine-merchant. Porcelaneous ware. Early Tang dynasty, ca. 625–675. Height: 15 in. (38 cm). Collection of Alexandra Munroe and Robert Rosenkranz.

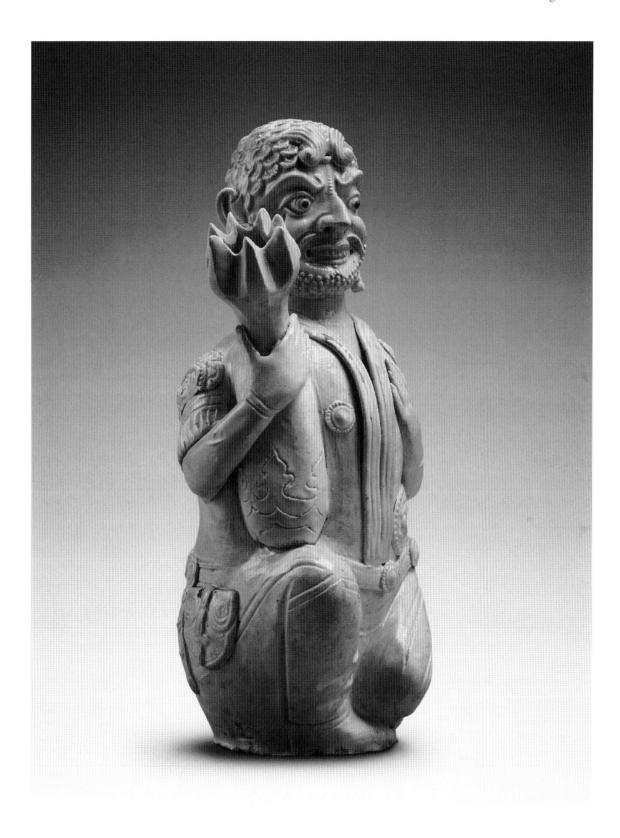

Figure 2 Figure of a Sogdian wine-merchant in Figure 1. Second view.

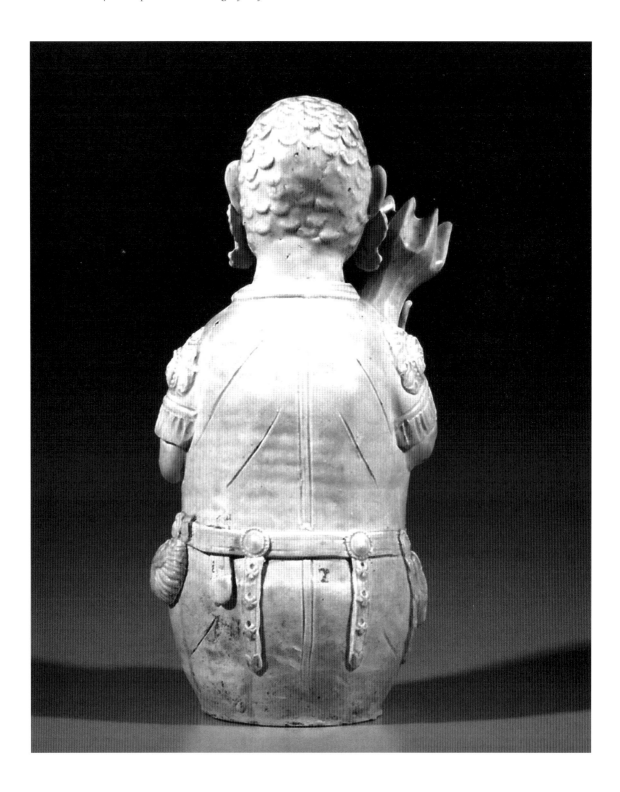

Figure 3 Figure of a Sogdian wine-merchant in Figures 1–2. Back view.

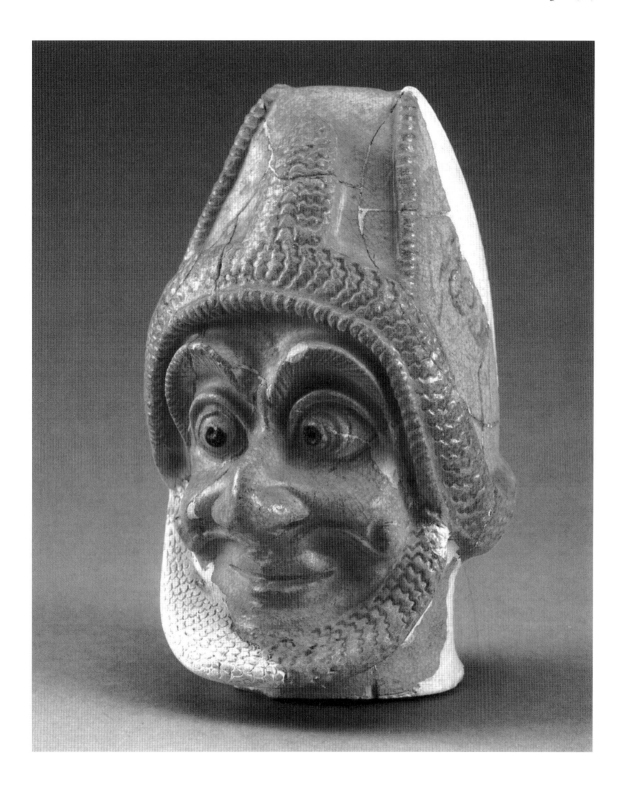

Figure 4 Head of a Sogdian. Porcelaneous ware. Datable to 661 or 667. From the Tang-dynasty tomb of Duan Boyang, Xi'an, Shaanxi. Height: 6½ in. (16.6 cm). Shaanxi Historical Museum.

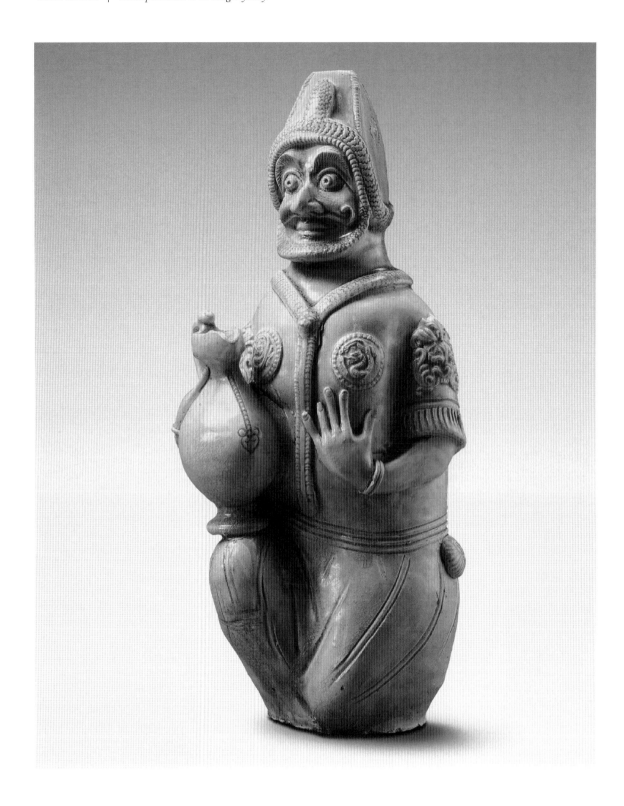

Figure 5 Figure of a Sogdian wine-merchant. Porcelaneous ware. Early Tang dynasty, ca. 625–675. Height: 20⅞ in. (53 cm). Formerly in the collection of Gisèle Croës.

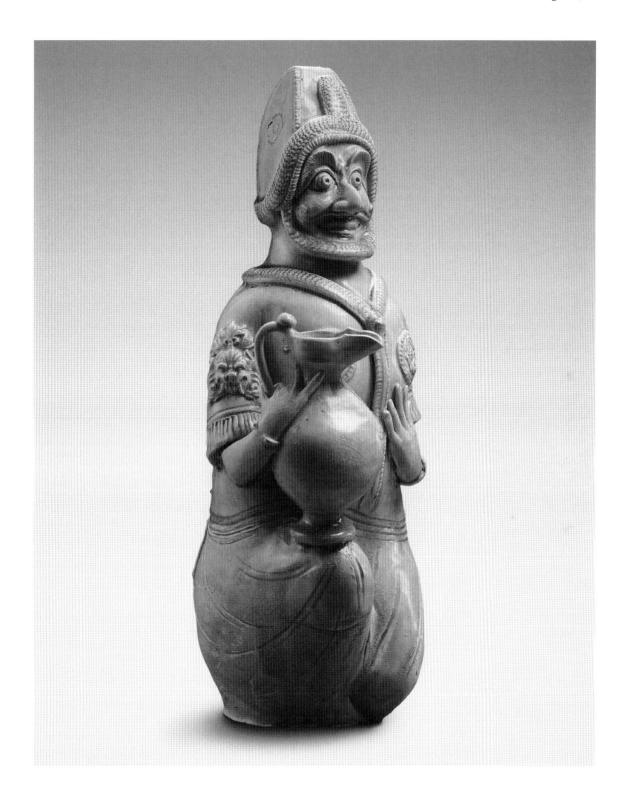

Figure 6 Figure of a Sogdian wine-merchant in Figure 5. Second view.

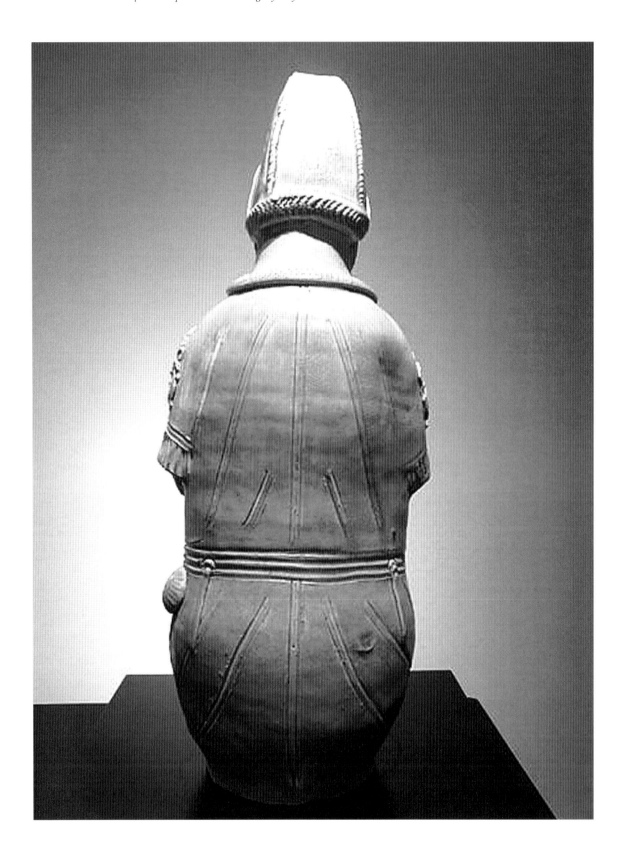

Figure 7 Figure of a Sogdian wine-merchant in Figures 5–6. Back view.

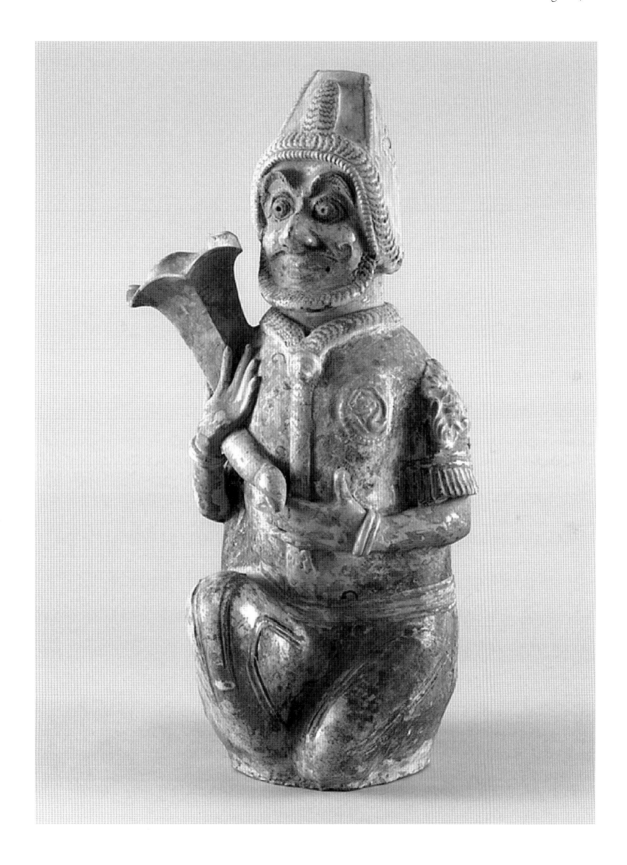

Figure 8 Figure of a Sogdian wine-merchant. Glazed-and-painted earthenware. Early Tang dynasty, ca. 625–675. Height: 15¾ in. (40 cm). Musée Cernuschi. Acquired with the assistance of des Amis du Musée Cernuschi, 1960. M. C. 8971.

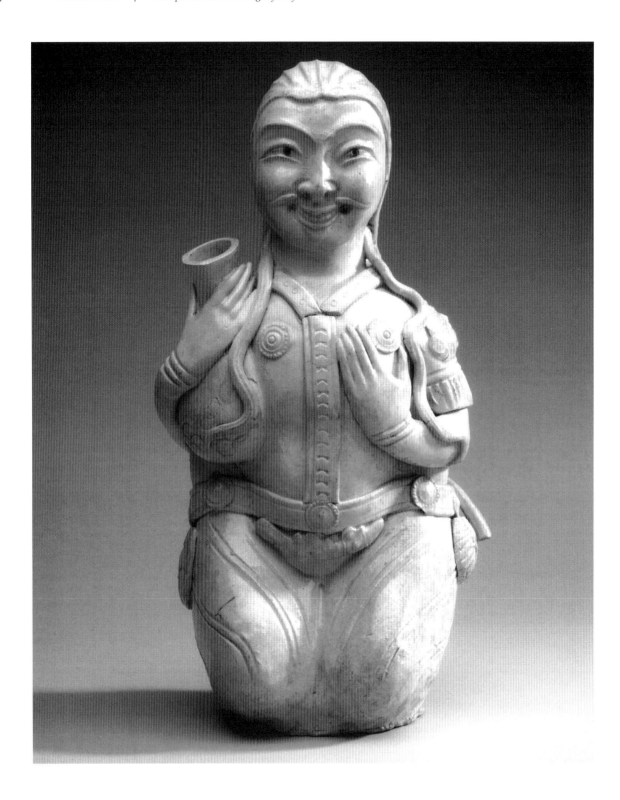

Figure 9 Figure of a Turkic nomad. Porcelaneous ware. Early Tang dynasty, ca. 625–675. Height: 14⅞ in. (37.7 cm). Royal Ontario Museum. The George Crofts Collection, Gift of Mrs. H. D. Warren. 918.23.38.

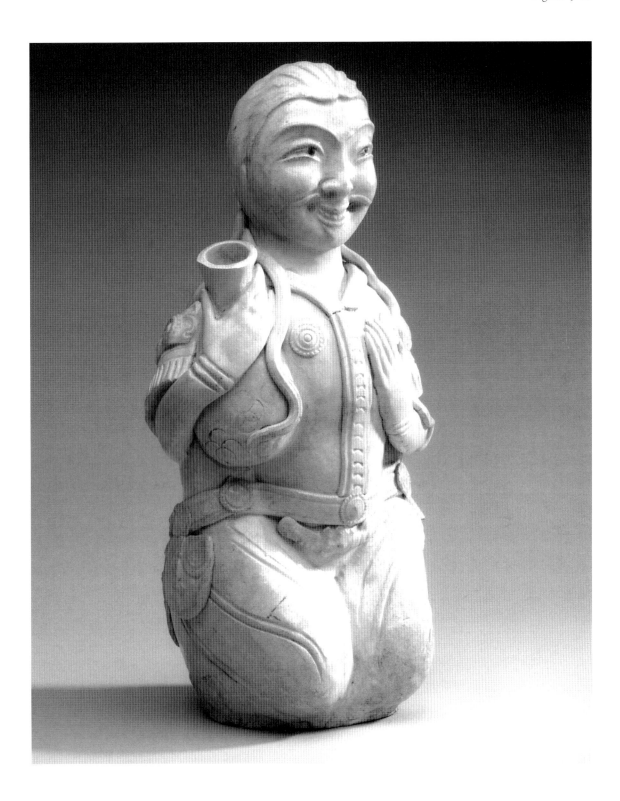

Figure 10 Figure of a Turkic nomad in Figure 9. Second view.

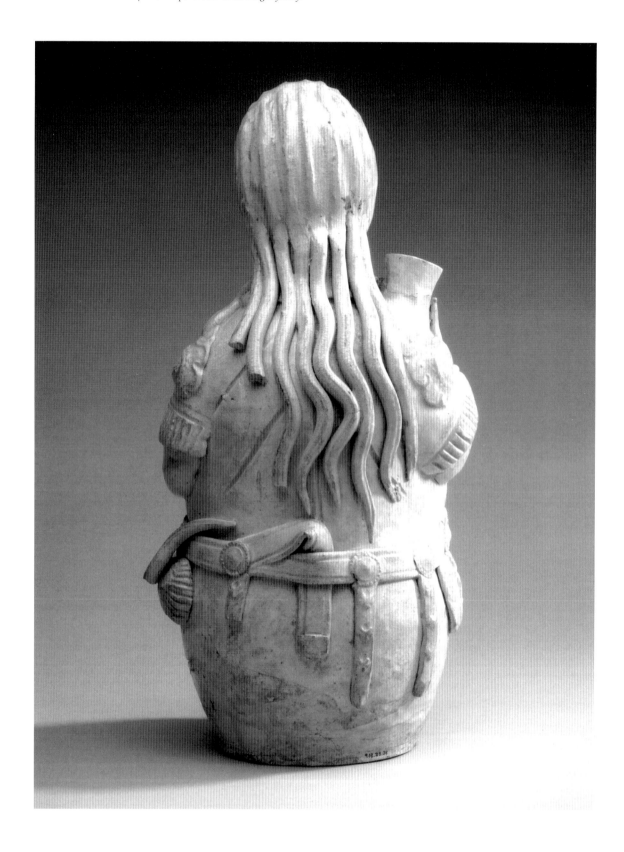

Figure 11 Figure of a Turkic nomad in Figures 9–10. Back view.

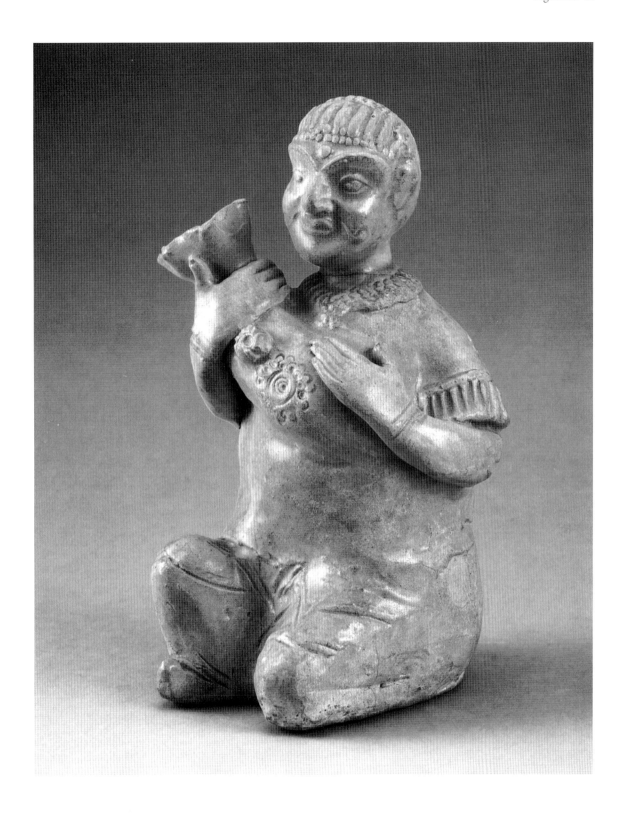

Figure 12 Figure of a Westerner. Porcelaneous ware. Datable to 661 or 667. From the Tang-dynasty tomb of Duan Boyang. Height: 9¼ in. (23.5 cm). Shaanxi Historical Museum.

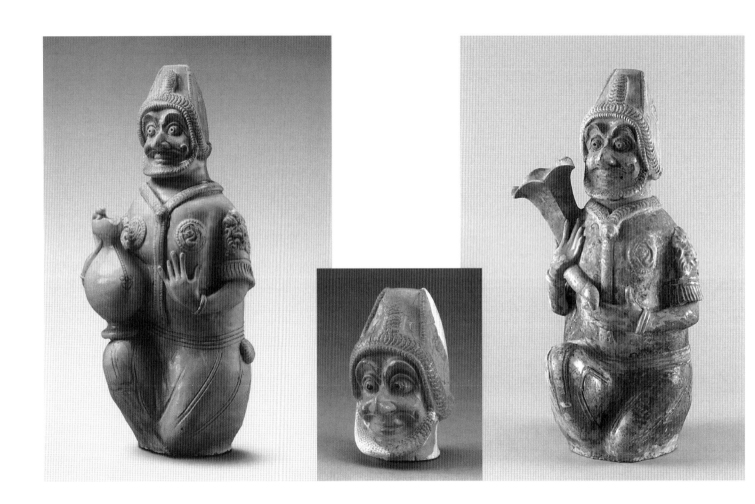

Figure 13 *Left*: Figure of a Sogdian wine-merchant in Figures 5–7.

Center: Head of a Sogdian in Figure 4.

Right: Figure of a Sogdian wine-merchant in Figure 8.

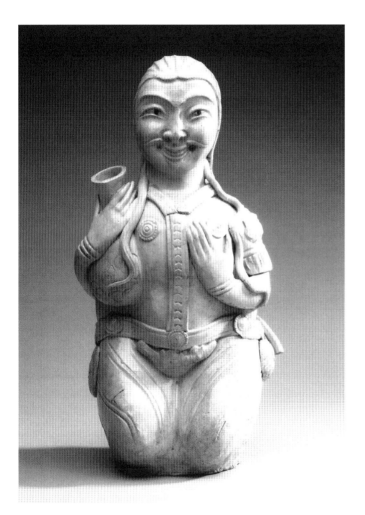 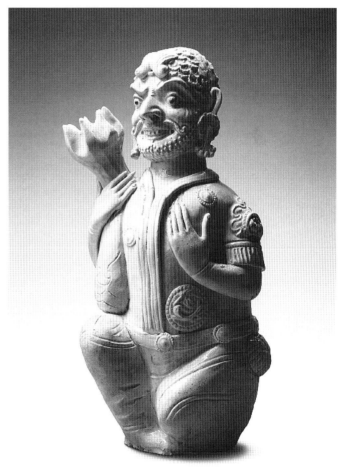

Figure 14 *Left*: Figure of a Turkic nomad in Figures 9–11.

Right: Figure of a Sogdian wine-merchant in Figures 1–3.

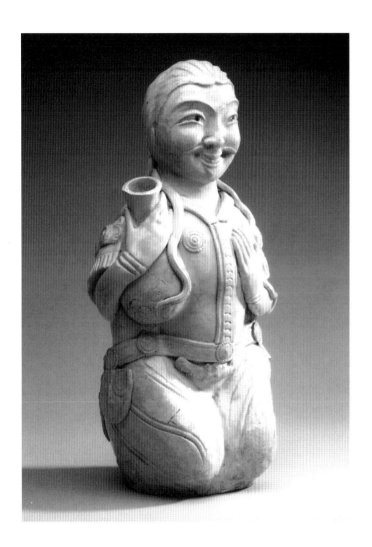 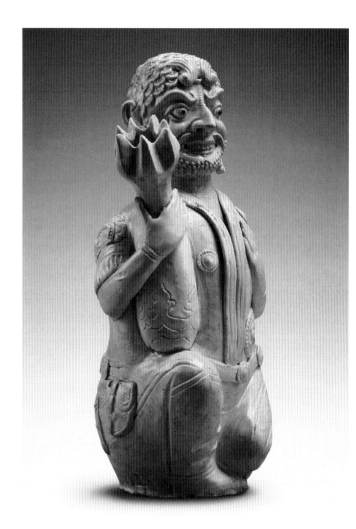

Figure 15 Left: Figure of a Turkic nomad in Figures 9–11.

Right: Figure of a Sogdian wine-merchant in Figures 1–3. Second views.

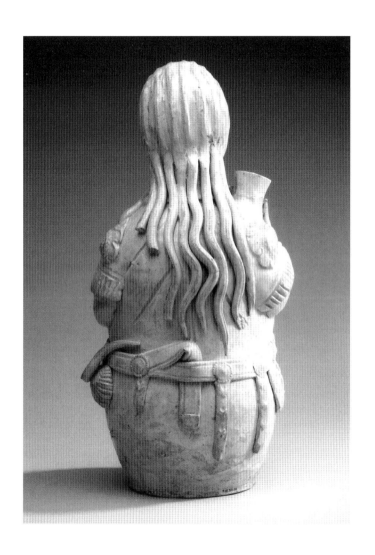 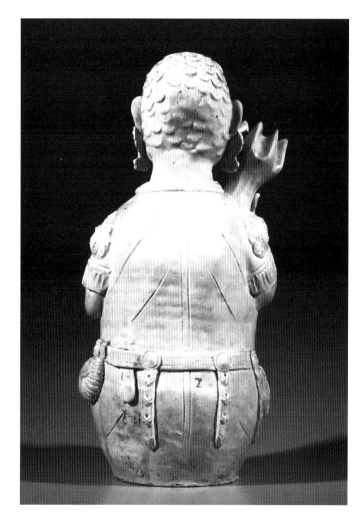

Figure 16 *Left*: Figure of a Turkic nomad in Figures 9–11.

Right: Figure of a Sogdian wine-merchant in Figures 1–3. Back views.

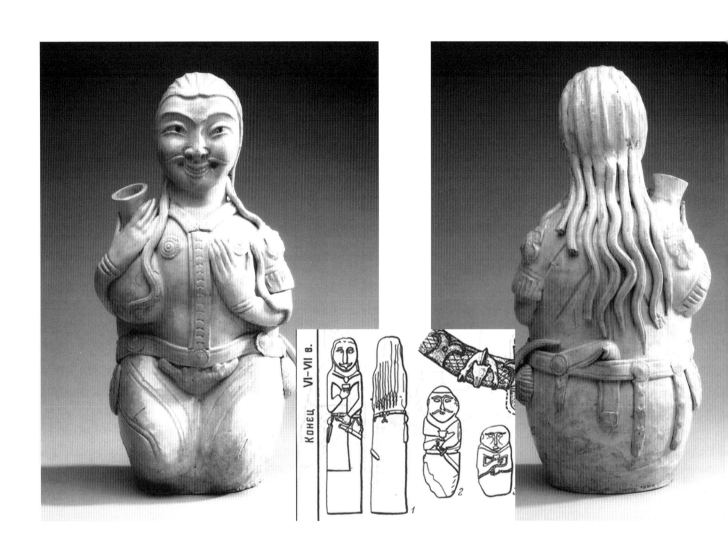

Figure 17 *Left* and *Right*: Figure of a Turkic nomad in Figures 9–11.

Center: Drawing of images of Turkic men with very long hair. From two Turkic kurgans, assigned to the sixth-to-seventh century, Kudyrge, Altai Mountains region of southern Siberia.

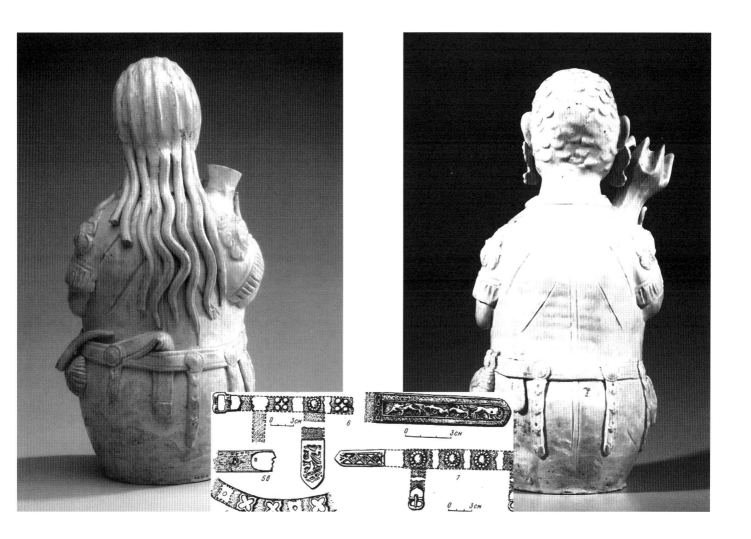

Figure 18 *Left*: Figure of a Turkic nomad in Figures 9–11. Back view.

Right: Figure of a Sogdian wine-merchant in Figures 1–3. Back view.

Center: Drawing of Turkic belts with pendent ornamented implements. From two Turkic kurgans, assigned to the sixth-to-seventh century, Kudyrge, Altai Mountains region of southern Siberia.

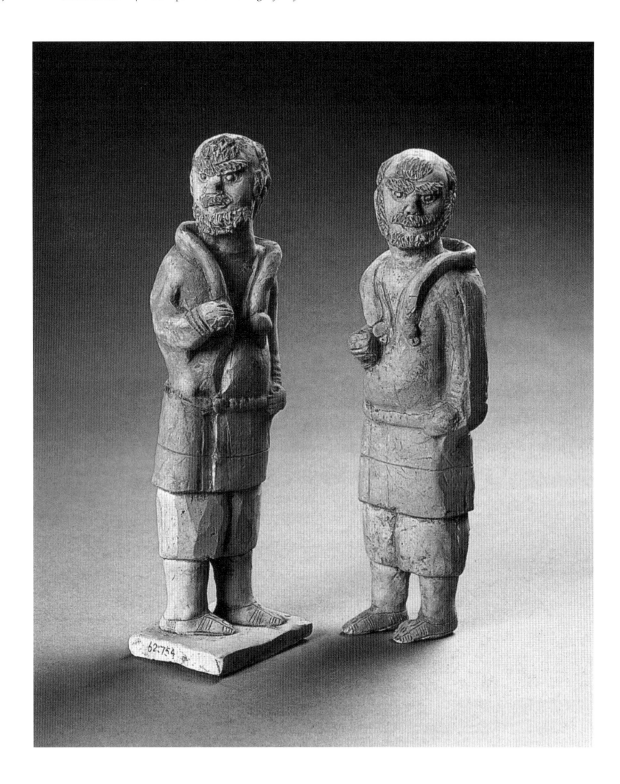

Figure 19 Pair of Westerners. Earthenware. From the Sui-dynasty tomb of General Zhang Sheng (buried 595), Anyang, Henan. Heights: 10⅝ in. (27 cm) and 10⅜ in. (26.3 cm). Henan Provincial Museum.

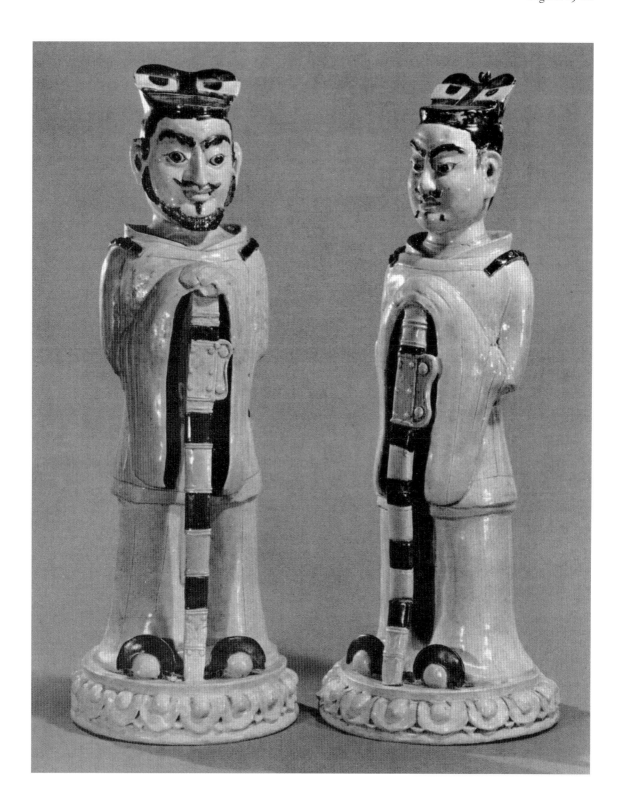

Figure 20 Pair of court officials. Porcelaneous ware. From the Sui-dynasty tomb of General Zhang Sheng (buried 595), Anyang, Henan. Heights: 28⅜ in. (72 cm). Henan Provincial Museum.

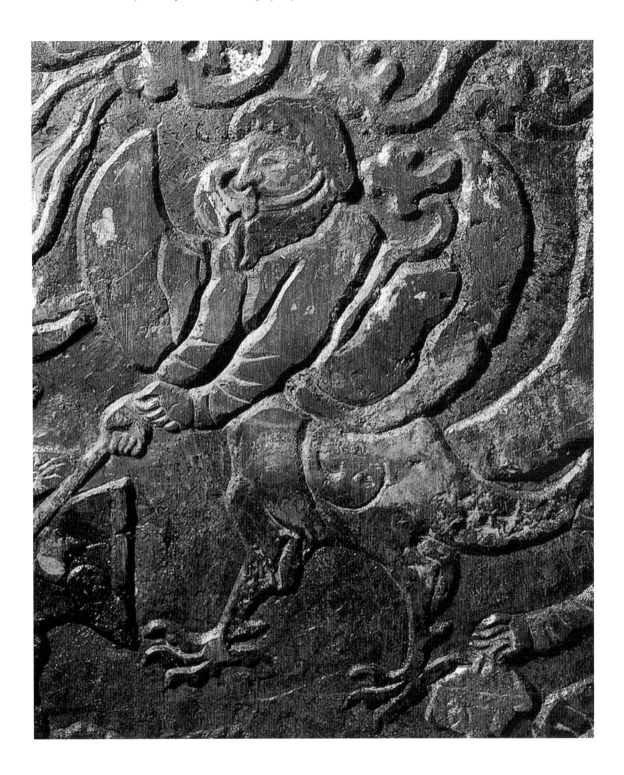

Figure 21 Detail of lunette above the entrance. Northern Zhou-dynasty tomb of An Jia (d. 579). Xi'an, Shaanxi.

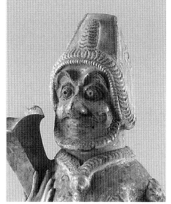
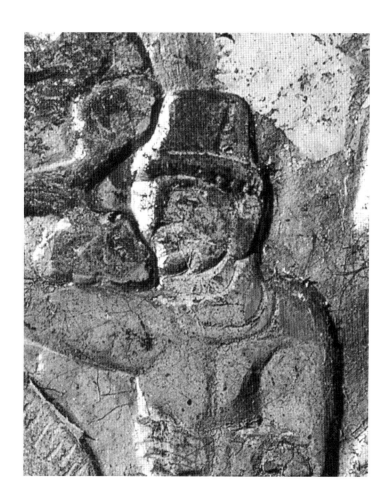
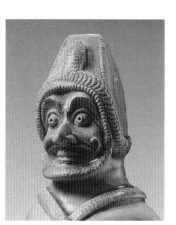

Figure 22 *Left, top*: Head of a Sogdian in Figures 4, 13.

Left, middle: Head of a Sogdian wine-merchant in Figures 8, 13.

Left, bottom: Head of a Sogdian wine-merchant in Figures 5–7, 13.

Right: Detail of carved-and-painted stone screen surrounding a stone couch. Northern Zhou-dynasty tomb of An Jia (d. 579).

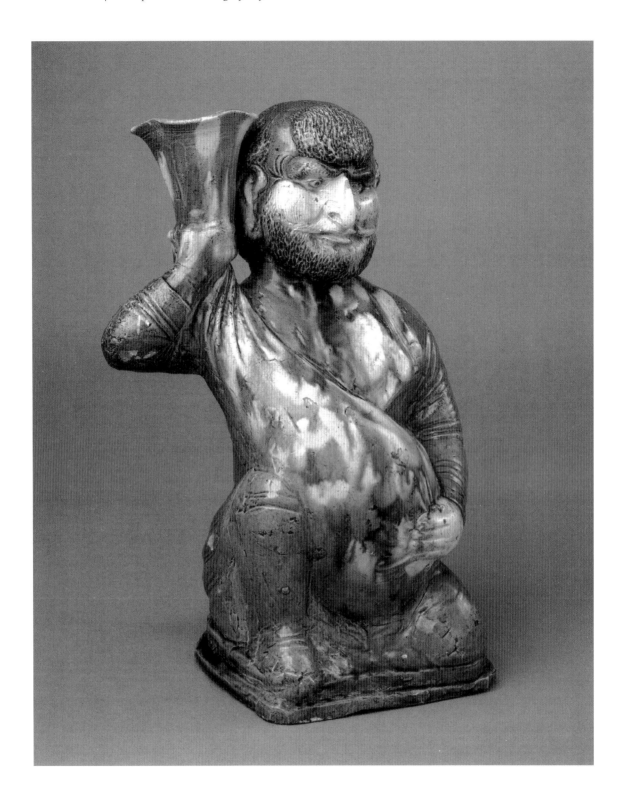

Figure 23 Figure of a Western wine-merchant. Earthenware with *sancai* (three-color) glazes. Tang dynasty, ca. first half eighth century. Height: 14⅜ in. (36.7 cm). Royal Ontario Museum. The George Crofts Collection. 918.21.7.

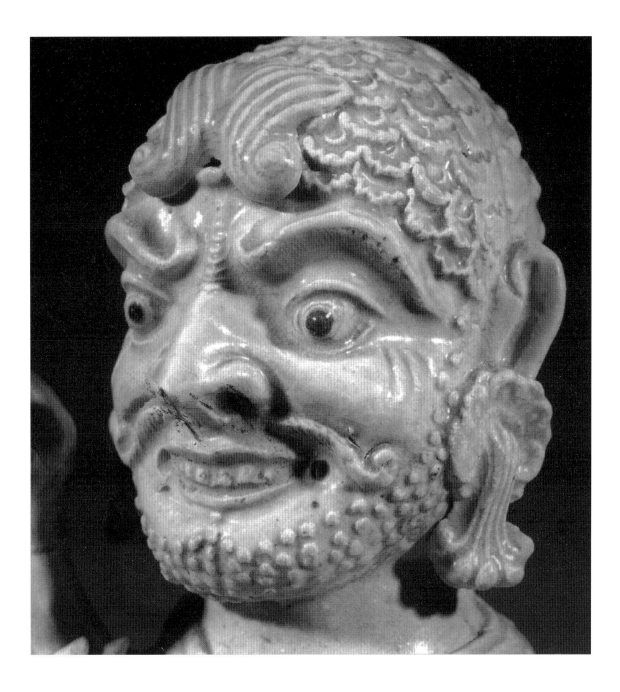

Figure 24 Head of a Sogdian wine-merchant in Figures 1–3, 14–16.

Figure 25 *Left*: Jar. Earthenware with relief decoration under green glaze. Northern Qi dynasty (550–577). Height: 13⅞ in. (35.3 cm). The Metropolitan Museum of Art. Purchase, Stanley Herzman Gift, 1996. 1996.15.

Center: Jar. Stoneware with relief decoration under celadon glaze. Northern Qi dynasty. Height: 7 in. (17.8 cm). The Metropolitan Museum of Art. Gift of Mr. and Mrs. Walter Kay, 2002. 2002.268.

Right: Head of a Bodhisattva. Limestone. From the northern Qi-dynasty southern Xiangtangshan caves, Handan, Hebei. Height: 15 in. (38.1 cm). The Metropolitan Museum of Art. Rogers Fund, 1914. 14.50.

Figure 26 *Detail*: epaulet. Figure of a Sogdian wine-merchant in Figures 1–3.

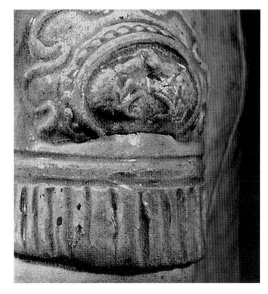

Figure 27 *Detail*: epaulet. Figure of a Sogdian wine-merchant in Figures 5–7.

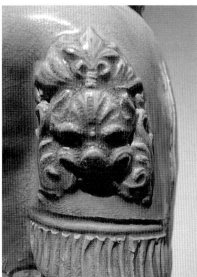

Figure 28 *Detail*: dragon set in a pearled roundel. Figure of a Sogdian wine-merchant in Figures 5–7.

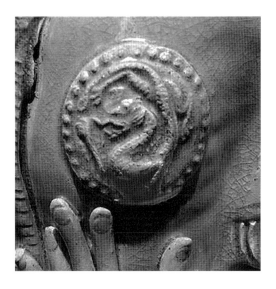

Glossary of Ceramic Technology

appliqué-relief. Attached ceramic ornaments, known as "appliqués," are formed in single clay molds, which are called "sprig molds." To produce an appliqué, unfired clay is pressed into the intaglio design of the pre-fired mold; an impression from the design produces an image in relief in the clay. The appliqué is released from the mold; the back is lightly scored and painted with a little liquid clay, or "slip." It then is pressed onto an area of the unfired ceramic object that also has been scored and slipped. The piece is generally, but not always, glazed; and then it is fired. These appliqués, apparently taken from a basic lexicon of motifs, could be used interchangeably in Tang-dynasty ceramics.

ceramics. All objects made from fired clay, including porcelain, porcelaneous ware, and stoneware, which are high-fired; and earthenware, which is low-fired. Synonymous with "pottery."

earthenware. A low-fired ceramic made from clay to which a proportion of other materials may be added to achieve good working and firing properties. Earthenware bodies are fairly soft; earthenware is porous and permeable; in color, it may range from white to light buff, tan, red, brown, or black, depending on the clay and the firing conditions.

Tang-dynasty northern Chinese earthenware mortuary figures and vessels were made from the same white-firing secondary kaolinic clays as the contemporary high-fired northern porcelaneous wares and porcelains. However, these tomb figures and vessels were under-fired to temperatures only high enough to mature their bodies to earthenware hardness.[1]

glaze. In essence, a glassy coating on the surface of a ceramic. A glaze serves the twofold function of helping to seal the clay body and decorating the object. Most glazes are composed predominantly of silica, with other materials, known as "fluxes," added to the silica, primarily to lower its melting point. There are two basic categories of old Chinese glazes:

*(1) **high-fired glazes*** that belong to the family of lime glazes, including lime-alkali glazes, in which calcium-oxide was employed as the principal fluxing agent. They were applied to unfired wares in the half-dry state, a technique known as "raw glazing,"[2] and the glazed object was given one firing at a kiln temperature high enough to mature the body and the glaze. These glazes can be found on late sixth- and seventh-century porcelaneous wares, where they are clear, heavily crazed, quite uneven, and can have a greenish tone where they are thick.

*(2) **low-fired glazes*** that belong to the family of lead glazes, in which lead-oxide was employed as the principal fluxing agent.[3] The majority of Tang-dynasty lead glazes are either green, a color derived from copper-oxide; amber brown, from iron-oxide; or dark blue, from cobalt-oxide. Tang *sancai* (three-color) glazes also include a creamy white, actually an uncolored glaze washed over the white body; as well as an occasional turquoise blue glaze that is derived from copper-oxide. These *sancai* glazes generally were applied to white-bodied earthenware vessels and mortuary figures that had been pre-fired, or "biscuit-fired," at temperatures of about 850°C.–1000°C.[4]

glazed-and-painted tomb figures. A category of Tang-dynasty white-bodied earthenware mortuary figures that were produced during the seventh century. They are decorated with low-fired lead glazes (these particular glazes can be creamy, yellowish, or straw-toned), as well as with unfired pigments and occasional gilt touches painted over the glaze.

mold-casting. Bodies and parts—such as heads, arms, or hands—of ceramic figures can be cast in two-part clay molds.[5] Unfired clay is pressed into the motifs carved into the interiors of the front and back halves of the pre-fired mold; an impression from the intaglio motifs produces images in relief in the clay. The two clay halves are released from the mold; they are luted together with a little slip, and the joins are smoothed out. After the molded parts—as well as any appliqué-relief ornamentation—have been attached to the mold-cast body,[6] the object usually is worked by hand to refine the cast. At this point, the piece can be (1) left unglazed and fired to maturity; (2) pre-fired, or biscuit-fired, in preparation for a low-fired glaze; or (3) receive a high-fired glaze and fired once to maturity.

porcelain and porceleneous ware. In the West, porcelain, strictly defined, is a high-fired ceramic that is white, translucent, hard, dense, impervious to liquid, and resonant when struck. Porcelaneous ware is a term sometimes used to denote wares that are superior to the average stonewares, yet not quite "true" porcelain in the Western sense. Dividing lines between these classifications are very subtle and in practice are not always possible to draw.[7]

The Chinese and Japanese generally classify all ceramics that are resonant when struck, whether they are white-bodied and translucent or not, under an all-inclusive term. They are called *ci* in China and *ji* in Japan; the written character is the same in both languages. *Ci* and *ji* may be labeled either porcelain, porcelaneous ware, or stoneware in Europe and America. These differences in nomenclature sometimes can make it difficult for Westerners to determine the character of early white wares described in Chinese archaeological reports.[8]

The raw materials used in the production of Chinese porcelain—basically white-burning kaolin, or "porcelain clay," and/or *petuntse*, or "porcelain stone"—varied considerably among different kiln-centers and at different times. For example, early northern Chinese porcelaneous wares were made from white-firing secondary kaolinic clays with little or no additives.[9] The firing temperature of Chinese porcelain ranges between 1250°C.–1400°C.[10]

stoneware. A vitrified, high-fired ceramic made of clay to which a proportion of other materials may be added to achieve good working and firing properties. Stoneware, which is fired in excess of about 1200°C., is dense, hard, resonant when struck, and impervious to liquid; it may be light or dark in color, but it is not translucent.

Endnotes

1 Wood 1999, 200.

2 Ibid., 30–31.

3 For early Chinese lead glazes, see "Early Northern Chinese Lead-Glazed Earthenwares" in Chapter 4, Ceramic Technology. For Tang-dynasty lead glazes, see Kerr and Wood in Needham 2004, 499–503; Wood 1999, 198–206.

4 Kerr and Wood in Needham 2004, 501.

5 For example, molds for Tang-dynasty earthenware figures have been excavated at the site of the Liquan kilns in modern Xi'an, Shaanxi Province. See "The Liquanfang Kilns" in Chapter 4, Ceramic Technology.

6 For two headless and armless bodies found at the Liquan kiln-site, see Shaanxi 2008, color pl. 106:2.

7 In such cases, the term "white wares" sometimes is substituted.

8 Bower 2010, 20; Kerr and Wood in Needham 2004, 9–11; Valenstein 1989, 59.

9 Wood 1999, 94.

10 Kerr and Wood in Needham 2004, 52.

Photograph Credits

Cover (front and back); page *ii*; figures 1–2, 5–6: Photo Studio Roger Asselberghs–Frédéric Dehaen; Courtesy of Gisèle Croës.

Figures 4, 12: Shaanxi Renmin Meishu Chubanshe.

Figures 7, 26–28: Courtesy of Gisèle Croës.

Figures 3, 24: Photographed by the author.

Figure 8: Stéphane Piera / Musée Cernuschi / Roger-Viollet.

Figures 9–11, 23: With permission of the Royal Ontario Museum © ROM.

Figures 17 *center*, 18 *center*: With permission of Academizdatcenter "Nauka," RAS.

Figure 19: By permission of the Elephant Press Co., Ltd. (Daxiang Chubanshe).

Figures 21–22: With permission of Wenwu Chubanshe (Cultural Relics Press).

Figures 25 *left*, *center*, and *right*: With permission of The Metropolitan Museum of Art. Image © The Metropolitan Museum of Art.

Maps by Anandaroop Roy.

Key to Shortened References

Abramson 2003
Abramson, Marc Samuel. "Deep Eyes and High Noses: Physiognomy and the Depiction of Barbarians in Tang China." In Nicola Di Cosmo and Don J. Wyatt, eds. *Political Frontiers, Ethnic Boundaries, and Human Geographies in Chinese History.* London and New York: Routledge Curzon, 2003:119–159.

Abramson 2008
———. *Ethnic Identity in Tang China.* Philadelphia: University of Pennsylvania Press, 2008.

Akiyama Terukazu and Matsubara Saburo 1969
Akiyama Terukazu and Matsubara Saburo. *Arts of China: Buddhist Cave Temples, New Researches.* Trans. Alexander C. Soper. Tokyo and Palo Alto: Kodansha International, 1969.

Aohanqi 1978
Aohanqi Wenhuaguan. "Aohanqi Lijiayingzi chutu de jin yin qi" [The gold and silver vessels excavated at Lijiayingzi, Aohan Banner]. *Kaogu* 1978.2: 117–118.

Arakawa Masaharu 2005
Arakawa Masaharu. "Sogdian Merchants and Chinese Han Merchants During the Tang Dynasty." In de la Vaissière and Trombert 2005: 231–242.

Azarpay et al. 1981
Azarpay, Guitty, et al. *Sogdian Painting: The Pictorial Epic in Oriental Art.* Berkeley and Los Angeles: University of California Press, 1981.

Barfield 1989
Barfield, Thomas J. *The Perilous Frontier: Nomadic Empires and China.* Cambridge, Mass.: Basil Blackwell, 1989.

Béguin, Maucuer, and Chollet 2000
Béguin, Gilles, Michel Maucuer, and Hélène Chollet. *Arts de l'Asie au Musée Cernuschi.* Paris: Paris-Musées, Ed. Findakly, 2000.

Beningson and Liu 2005
Beningson, Susan L., and Cary Y. Liu. *Providing for the Afterlife: "Brilliant Artifacts" from Shandong.* Exh. cat. New York: China Institute in America, 2005.

Bobot 1983
Bobot, Marie-Thérèse. *Musée Cernuschi: Promenade dans les Collections Chinoises.* Paris: Les Musées de la Ville de Paris, 1983.

Boulnois 2004
Boulnois, Luce. *Silk Road: Monks, Warriors and Merchants on the Silk Road.* Trans. Helen Loveday, with additional material by Bradley Mayhew and Angela Sheng. Hong Kong: Odyssey Books and Guides, 2004.

Bower 1982
Bower, Virginia L. "Tomb Ceramics: The Spirit of the Living." In Thorp and Bower 1982: 39–45; cat. nos. 24–52.

Bower 2002
———. *From Court to Caravan: Chinese Tomb Sculptures from the Collection of Anthony M. Solomon.* Exh. cat. Cambridge, Mass.: Harvard University Art Museums, 2002.

Bower 2010
———. "Introduction." In Li Zhiyan, Bower, and He Li 2010: 17–29.

Cao Zhezhi and Sun Binggen 1996
Cao Zhezhi and Sun Binggen, eds. *Zhongguo gudai yong* [Ancient Chinese figures]. Shanghai: Shanghai Wenhua Chubanshe, 1996.

Cheng Yue 1996
Cheng Yue. "A Summary of Sogdian Studies in China." *China Archaeology and Art Digest*, vol. 1, no. 1 (May 1996): 21–30. From *Zhongguo shi yanjiu dongtai*, no. 9 (1995): 13–19.

Cixian 1984
Cixian Wenhuaguan. "Hebei Cixian Dong Wei Ruru gongzhu mu fajue jianbao" [A report of the excavation of the Eastern Wei tomb of a Ruru Princess at Cixian, Hebei]. *Wenwu* 1984.4: 1–9.

Croës 2008a
Croës, Gisèle. *Treasures of Ancient Chinese Culture.* Sale cat. New York, March 2008. Brussels: Gisèle Croës, 2008.

Croës 2008b
———. *Arts D'Extrême Orient.* Sale cat. Paris, September 2008. Brussels: Gisèle Croës, 2008.

Daikō 2004
Daikō Company, Ltd., organizers. *Tōsansai ten: Rakuyō no yume/Three-color ware of the Tang dynasty: The Henan Province discoveries*. Exh. cat. Osaka: Daikō Company, Ltd., 2004.

Dien 1987
Dien, Albert E. "Chinese Beliefs in the Afterworld." In Los Angeles County Museum 1987: 1–15.

Dien 2007
———. *Six Dynasties Civilization*. New Haven and London: Yale University Press, 2007.

Duan Qingbo 2007
Duan Qingbo. "Entertainment for the Afterlife." In Portal 2007: 192–203.

Dyakonova and Sorokin 1960
Dyakonova, N. V., and S. S. Sorokin. *Khotanskie drevnosti, katalog: terrakota i shtuk* [Catalogue of Khotanese terracotta and stucco antiquities]. Leningrad: The Hermitage Museum, 1960.

Feng Xianming 1983
Feng Xianming. "Cong Lou Rui mu chutu wenwu tan Bei Qi taoci tezheng" [A discussion of the cultural relics excavated from the Lou Rui tomb: Characteristics of the Northern Qi ceramics]. *Wenwu* 1983.10: 30–32.

Feng Xianming et al. 1982
Feng Xianming et al., eds. *Zhongguo taoci shi* [History of Chinese ceramics]. Beijing: Wenwu Chubanshe, 1982.

Fong 1991
Fong, Mary H. "Antecedents of Sui–Tang Burial Practices in Shaanxi." *Artibus Asiae*, vol. 51:3/4 (1991): 147–198.

Fong Wen 1980
Fong Wen, ed. *The Great Bronze Age of China: An Exhibition from the People's Republic of China*. Exh. cat. New York: The Metropolitan Museum of Art, 1980.

Fontein and Wu Tung 1973
Fontein, Jan, and Wu Tung. *Unearthing China's Past*. Exh. cat. Boston: Museum of Fine Arts, 1973.

Golden 1992
Golden, Peter B. *An Introduction to the History of the Turkic Peoples: Ethnogenesis and State Formation in Medieval and Early Modern Eurasia and the Middle East*. Wiesbaden: Otto Harrassowitz, 1992.

Grenet 2005
Grenet, Frantz. "The Self-image of the Sogdians." In de la Vaissière and Trombert 2005: 123–140, 440.

Hansen 2012
Hansen, Valerie. *The Silk Road: A New History*. New York: Oxford University Press, 2012.

Hearn 1980
Hearn, Maxwell K. "The Terracotta Army of the First Emperor of Qin (221–206 BC)." In Fong Wen 1980: 353–373.

Henan 1972
Henan Sheng Bowuguan. "Henan Anyang Bei Qi Fan Cui mu fajue jianbao" [A report of the excavation of the Northern Qi tomb of Fan Cui at Anyang, Henan]. *Wenwu* 1972.1: 47–57, 86.

Henan 2000
Henan Sheng Gongyi Shi Wenwu Baohu Guanli Suo, ed. *Huangye Tang sancai yao/Three-color glazed pottery kilns of the Tang dynasty at Huangye*. Beijing: Kexue Chubanshe, 2000.

Henan 1958
Henan Sheng Wenhuaju Wenwu Gongzuodui. *Dengxian caise huaxiang zhuan mu* [The tomb with bricks with colored painted images at Dengxian]. Beijing: Wenwu Chubanshe, 1958.

Henan 2009
Henan Sheng Wenwu Kaogu Yanjiusuo, Zhongguo Wenhua Yichan Yanjiuyuan, and Riben Nailiang Wenhua Cai Yanjiusuo. *Gongyi Baihe yao kaogu xin faxian/The new archaeological discovery at Baihe kiln in Gongyi*. Zhengzhou: Da Xiang Chubanshe, 2009.

Henan 2005
Henan Sheng Wenwu Kaogu Yanjiusuo, Zhongguo Wenwu Yanjiusuo, and Riben Nailiang Wenhua Cai Yanjiusuo, eds. *Huangye yao kaogu xin faxian/The new archaeological discovery at Huangye kiln site*. Zhengzhou: Da Xiang Chubanshe, 2005.

Henan 1983
Henan Sheng Wenwu Yanjiusuo, ed. *Chūgoku sekkutsu: Kyōken sekkutsu-ji* [The caves of China: Gongxian cave-temples]. Tokyo: Heibonsha, 1983.

Hong Kong and Qingzhou 2001
Hong Kong Museum of Art and Qingzhou City Museum. *Shandong Qingzhou Longxing si chutu fojiao zaoxiang zhan/Buddhist sculptures: New discoveries from Qingzhou, Shandong Province*. Exh. cat. Hong Kong: Leisure and Cultural Services Department, 2001.

Howard et al. 2006
Howard, Angela Falco, et al. *Chinese Sculpture*. New Haven and London: Yale University Press. Beijing: Foreign Language Press, 2006.

Hubei 1989
Hubei Sheng Bowuguan. *Zeng Hou Yi mu/Tomb of Marquis Yi of state Zeng*. 2 vols. Beijing: Wenwu Chubanshe, 1989.

Idemitsu 1987
Idemitsu Bijutsukan. *Chūgoku tōji: Idemitsu Bijutsukan zōhin zuroku/Chinese ceramics in the Idemitsu collection*. Tokyo: Heibonsha, 1987.

Jagchid and Symons 1989
Jagchid, Sechin, and Van Jay Symons. *Peace, War, and Trade Along the Great Wall: Nomadic-Chinese Interaction through Two Millennia*. Bloomington and Indianapolis: Indiana University Press, 1989.

Juliano 1975
Juliano, Annette L. *Art of the Six Dynasties: Centuries of Change and Innovation*. Exh. cat. New York: China Institute in America, 1975.

Juliano 1980
———. *Teng-hsien: An Important Six Dynasties Tomb*. Ascona: Artibus Asiae, 1980.

Juliano and Lerner 2001a
Juliano, Annette L., and Judith A. Lerner. *Monks and Merchants: Silk Road Treasures from Northwest China: Gansu and Ningxia, 4th–7th Century*. Exh. cat. New York: Harry N. Abrams, 2001.

Juliano and Lerner 2001b
———. "The Miho Couch Revisited in Light of Recent Discoveries." *Orientations*, vol. 32, no. 8 (October 2001): 54–61.

Juliano and Lerner 2001c
———. "The Silk Road in Gansu and Ningxia." In Juliano and Lerner 2001a: 21–36.

Kamei Meitoku 1998–1999
Kamei Meitoku. "Nanbokuchō-ki chō kamon seishi no kenkyū" [The study of Southern and Northern Dynasties celadons decorated with applied ornaments]. *Toyo toji*, vol. 28 (1998-1999): 79–116.

Kaogu 1959
Kaogu Yanjiusuo Anyang Fajuedui. "Anyang Sui Zhang Sheng mu fajue ji" [A record of the excavation of the Sui tomb of Zhang Sheng at Anyang]. *Kaogu* 1959.10: 541–545.

Karetzky 2001
Karetzky, Patricia. "The Presence of the Goddess Anahita and Cosmological Symbols Associated with the Goddess on Western Decorative Arts Excavated in Early Medieval China." In Wu Hung, ed. *Between Han and Tang: Cultural and Artistic Interaction in a Transformative Period*. Beijing: Wenwu Chubanshe, 2001: 341–384.

Krahl et al. 2010
Krahl, Regina, et al., eds. *Shipwrecked: Tang Treasures and Monsoon Winds*. Exh. cat. Washington, D.C.: Smithsonian Institution; Singapore: National Heritage Board; Singapore: Singapore Tourist Board, 2010.

Knauer 1998
Knauer, Elfriede Regina. *The Camel's Load in Life and Death: Iconography and Ideology of Chinese Pottery Figurines from Han to Tang and Their Relevance to Trade Along the Silk Routes*. Zürich: Akanthus, 1998.

Kuwayama 1987
Kuwayama, George. "The Sculptural Development of Ceramic Funerary Figures in China." In Los Angeles County Museum 1987: 63–93.

de la Vaissière 2005
de la Vaissière, Étienne. *Sogdian Traders: A History*. Trans. James Ward. Leiden and Boston: Brill, 2005.

de la Vaissière and Trombert 2005
de la Vaissière, Étienne, and Éric Trombert, eds. *Les Sogdiens en Chine*. Paris: École française d'Extrême-Orient, 2005.

Ledderose 2000
Ledderose, Lothar. *Ten Thousand Things: Module and Mass Production in Chinese Art*. Princeton: Princeton University Press, 2000.

Lerner 2001
Lerner, Judith A. "The Merchant Empire of the Sogdians." In Juliano and Lerner 2001a: 221–229.

Li Xixing and Chen Zhiqian 1991
Li Xixing and Chen Zhiqian. *Zhaoling wenwu jinghua/Select relics from Zhaoling Mausoleum*. Xi'an: Shaanxi Renmin Meishu Chubanshe, 1991.

Li Zhiyan 2010a
Li Zhiyan. "Prehistoric Earthenware." In Li Zhiyan, Bower, and He Li 2010: 31–89.

Li Zhiyan 2010b
———. "Ceramics of the Warring States Period and the Qin and Han Dynasties." In Li Zhiyan, Bower, and He Li 2010: 117–159.

Li Zhiyan 2010c
———. "Ceramics of the Sui, Tang, and Five Dynasties." In Li Zhiyan, Bower, and He Li 2010: 197–263.

Li Zhiyan, Bower, and He Li 2010
Li Zhiyan, Virginia L. Bower, and He Li, eds. *Chinese Ceramics: From the Paleolithic Period through the Qing Dynasty*. New Haven and London: Yale University Press. Beijing: Foreign Languages Press, 2010.

Liaoning and Chaoyang 1998
Liaoning Sheng Wenwu Kaogu Yanjiusuo and Chaoyang Shi Bowuguan. "Liaoning Chaoyang Bei Chao ji Tang dai muzang" [The Northern Dynasties and Tang-dynasty tombs at Chaoyang, Liaoning]. *Wenwu* 1998.3: 4–26.

Lin 2007
Lin, James. "Armour for the Afterlife." In Portal 2007: 181–191.

Liu 2005a
Liu, Cary Y. "The Concept of 'Brilliant Artifacts' in Han-Dynasty Burial Objects and Funerary Architecture: Embodying the Harmony of the Sun and the Moon." In Liu, Nylan, and Barbieri-Low 2005: 205–221.

Liu 2005b
———. "Embodying the Harmony of the Sun and the Moon: The Concept of 'Brilliant Artifacts' in Han Dynasty Burial Objects and Funerary Architecture." In Beningson and Liu 2005: 17–29.

Liu, Nylan, and Barbieri-Low 2005
Liu, Cary Y., Michael Nylan, and Anthony Barbieri-Low. *Recarving China's Past: Art, Archaeology, and Architecture of the "Wu Family Shrines."* Princeton: Princeton University Art Museum, 2005.

Liu Hongmiao, Sun Jiaoyun, and Zhang Xinyue 2005
Liu Hongmiao, Sun Jiaoyun, and Zhang Xinyue. "Henan Gongyi chutu Sui dai bai ci qian yi"/"Some remarks on the Sui-dynasty white wares excavated in Gongyi, Henan." In Shanghai 2005: 257–266.

Longmen and Beijing 1991
Longmen Wenwu Baoguansuo and Beijing Daxue Kaoguxi, eds. *Zhongguo shiku: Longmen shiku* [The caves of China: Longmen caves]. 2 vols. Beijing: Wenwu Chubanshe, 1991.

Los Angeles County Museum 1987
Los Angeles County Museum of Art. *The Quest for Eternity: Chinese Ceramic Sculptures from the People's Republic of China.* Exh. cat. Los Angeles: Los Angeles County Museum of Art; San Francisco: Chronicle Books, 1987.

Luo Feng 2000
Luo Feng. "*Sabao:* Further Consideration of the Only Post for Foreigners in the Tang Dynasty Bureaucracy." Trans. Bruce Doar. *China Archaeology and Art Digest: Zoroastrianism in China*, vol. 4, no. 1 (December 2000): 165–191. From *Tang yanjiu*, no. 4 (December 1998): 215–249.

Luo Feng 2001
———. "Sogdians in Northwest China." In Juliano and Lerner 2001a: 239–245.

Luoyang 1973
Luoyang Bowuguan. "Luoyang Bei Wei Yuan Zhao mu" [The Northern Wei tomb of Yuan Zhao at Luoyang]. *Kaogu* 1973.4: 218–224, 243.

Luoyang 2010
———. "Tang sancai jiu hu" [Tang three-color wine flasks]. Luoyang Bowuguan Website, October 29, 2010, http://www.lymuseum.com/?action=5&bid=20&cid=21&did=65.

Mahler 1959
Mahler, Jane Gaston. *The Westerners Among the Figurines of the T'ang Dynasty of China.* Rome: Istituto Italiano Per Il Medio Ed Estremo Oriente, 1959.

Mair 2004
Mair, Victor H. "The North(west)ern Peoples and the Recurrent Origins of the 'Chinese' State." In Joshua A. Fogel, ed. *The Teleology of the Modern Nation-State: Japan and China.* Philadelphia: University of Pennsylvania Press, 2004: 46–84, 205–217.

Mallory and Mair 2000
Mallory, J. P., and Victor H. Mair. *The Tarim Mummies: Ancient China and the Mystery of the Earliest Peoples from the West.* London: Thames and Hudson, 2000.

Marshak 2001
Marshak, Boris I. "The Sogdians in Their Homeland." In Juliano and Lerner 2001a: 231–237.

Marshak 2004
———. In Watt et al. 2004: cat. no. 208.

McGovern 2009
McGovern, Patrick E. *Uncorking the Past: The Quest for Wine, Beer, and Other Alcoholic Beverages.* Berkeley, Los Angeles, and London: University of California Press, 2009.

Mengjin 1993
Mengjin Kaogudui. "Luoyang Mengjin Xishantou Tang mu fajue baogao" [A report of the excavation of Tang tombs at Xishantou, Mengjin, Luoyang]. *Huaxia kaogu* 1993.1: 52–68.

Michaelson 1999
Michaelson, Carol. *Gilded Dragons: Buried Treasures from China's Golden Ages.* Exh. cat. London: British Museum Press, 1999.

Needham 2000
Needham, Joseph. *Science and Civilisation in China.* Vol. 6, *Biology and Biological Technology*; part 5, *Fermentations and Food Science.* By H. T. Huang (Huang Hsing-tsung). Cambridge, England: Cambridge University Press, 2000.

Needham 2004
———. *Science and Civilisation in China.* Vol. 5, *Chemistry and Chemical Technology*; part 12, *Ceramic Technology.* Rose Kerr, ed. By Rose Kerr and Nigel Wood. Cambridge, England: Cambridge University Press, 2004.

Nickel 2007
Nickel, Lukas. "The Terracotta Army." In Portal 2007: 159–179.

Norell and Leidy 2011
Norell, Mark, and Denise Patry Leidy, with Laura Ross. *Traveling the Silk Road: Ancient Pathway to the Modern World.* New York: Sterling Signature, 2011.

Pletneva 1981
Pletneva, S. A., ed. *Stepi Evrazii v epokhu srednevekov'ia* [The Eurasian Steppes in the Middle Ages]. Moscow: Arkheologiia SSSR, 1981.

Portal 2007
Portal, Jane, ed. *The First Emperor: China's Terracotta Army.* Exh. cat. London: British Museum Press, 2007.

Proctor 1979
Proctor, Patricia. "Royal Ontario Museum, Far Eastern Department: Chinese Ceramics." *Arts of Asia*, vol. 9, no. 2 (March–April 1979): 84–105.

Qianling 2008
Qianling Bowuguan. *Si lu hu ren wailai feng: Tang dai hu yong zhan/Exotic flavor of the foreigners on the Silk Road: Terracotta hu man* [sic] *of the Tang dynasty.* Exh. cat. Beijing: Wenwu Chubanshe, 2008.

Quan Kuishan 2010
Quan Kuishan. "Ceramics of the Period of Division." In Li Zhiyan, Bower, and He Li 2010: 161–195.

Quan Kuishan, Ding Pengbo, and Li Zhiyan 2010
Quan Kuishan, Ding Pengbo, and Li Zhiyan. "Ceramics of the Xia, Shang, and Western Zhou Dynasties and the Spring and Autumn Period." In Li Zhiyan, Bower, and He Li 2010: 91–115.

Rawson 1984
Rawson, Jessica. *Chinese Ornament: The Lotus and The Dragon.* London: British Museum Publications, 1984.

Rawson 1992a
———. ed. *The British Museum Book of Chinese Art.* London: British Museum Press, 1992.

Rawson 1992b
———. "Tomb Sculpture." In Rawson 1992a: 138–145.

Rawson 1996
———. ed. *Mysteries of Ancient China: New Discoveries from the Early Dynasties.* Exh. cat. London: British Museum Press, 1996.

Rong Xinjiang 2000
Rong Xinjiang. "The Migrations and Settlements of the Sogdians in the Northern Dynasties, Sui and Tang." Trans. Bruce Doar. *China Archaeology and Art Digest*, vol. 4, no. 1 (December 2000): 117–163. From *Guoxue yanjiu*, no. 6 (1999).

Rong Xinjiang and Zhang Zhiqing 2004
Rong Xinjiang and Zhang Zhiqing, eds. *Cong Samaergan dao Chang'an: Sute ren zai Zhongguo de wenhua yiji/From Samarkand to Chang'an: Cultural traces of the Sogdians in China.* Exh. cat. Beijing: Beijing Tushuguan Chubanshe, 2004.

Royal Ontario 1992
Royal Ontario Museum. *Homage to Heaven, Homage to Earth: Chinese Treasures of the Royal Ontario Museum.* Toronto: University of Toronto Press, 1992.

Schafer 1963
Schafer, Edward H. *The Golden Peaches of Samarkand: A Study of T'ang Exotics.* Berkeley and Los Angeles: University of California Press, 1963.

Sensabaugh 2010
Sensabaugh, David Ake. "Foreword." In Li Zhiyan, Bower, and He Li 2010: xiv-xv.

Shaanxi 1977
Shaanxi Sheng Bowuguan. "Tang Li Feng mu fajue jianbao" [A report of the excavation of the Tang tomb of Li Feng]. *Kaogu* 1977.5: 313–326.

Shaanxi 1972
Shaanxi Sheng Bowuguan, Liquan Xian Wenjiao Ju, and Tang Mu Fajue Zu. "Tang Zheng Rentai mu fajue jianbao" [A report of the excavation of the Tang tomb of Zheng Rentai]. *Wenwu* 1972.7: 33–44.

Shaanxi 1992
Shaanxi Sheng Kaogu Yanjiusuo. *Tang dai Huangpu yao zhi/Excavation of a Tang kiln-site at Huangpu in Tongchuan, Shaanxi.* 2 vols. Beijing: Wenwu Chubanshe, 1992.

Shaanxi 2001
———. "Xi'an faxian de Bei Zhou An Jia mu" [The discovery of the Northern Zhou tomb of An Jia at Xi'an]. *Wenwu* 2001.1: 4–26.

Shaanxi 2003
———. ed. *Xi'an Bei Zhou An Jia mu* [The Northern Zhou tomb of An Jia at Xi'an]. Beijing: Wenwu Chubanshe, 2003.

Shaanxi 2008
———. *Tang Chang'an Liquanfang sancai yao zhi/The kiln site of tricolor-glazed pottery at Liquanfang in Chang'an, capital city of Tang dynasty.* Beijing: Wenwu Chubanshe, 2008.

Shaanxi 2009
———. "Xi'an nan jiao Sui Li Yu mu fajue jianbao" [A report of the excavation of the Sui tomb of Li Yu in the southern suburbs of Xi'an]. *Wenwu* 2009.7: 4–20.

Shaanxi and Zhaoling 1978
Shaanxi Sheng Wenguanhui and Zhaoling Wenguansuo. "Shaanxi Liquan Tang Zhang Shigui mu" [The Tang tomb of Zhang Shigui in Liquan, Shaanxi]. *Kaogu* 1978.3: 168–178.

Shaanxi 1960
Shaanxi Sheng Wenwu Guanli Weiyuanhui. "Jieshao ji jian Shaanxi chutu de Tang dai qingci qi" [Introducing several Tang-dynasty celadon vessels excavated in Shaanxi]. *Wenwu* 1960.4: 48.

Shaanxi and Liquan 1977
Shaanxi Sheng Wenwu Guanli Weiyuanhui and Liquan Xian Zhaoling Wenguansuo. "Tang Ashina Zhong mu fajue jianbao" [A report of the excavation of the Tang tomb of Ashina Zhong]. *Kaogu* 1977.2: 132–138, 80.

Shanghai 2005
Shanghai Bowuguan, ed. *Zhongguo gudai bai ci guoji xueshu yantao hui lun wenji/Symposium on ancient Chinese white porcelain: Proceedings, 2002: Shanghai Bowuguan.* Shanghai: Shanghai Shuhua Chubanshe, 2005.

Shanxi and Shanxi 1972
Shanxi Sheng Datong Shi Bowuguan and Shanxi Sheng Wenwu Gongzuo Weiyuanhui. "Shanxi Datong Shijiazhai Bei Wei Sima Jinlong mu" [The Northern Wei tomb of Sima Jinlong at Shijiazhai, Datong, Shanxi]. *Wenwu* 1972.3: 20–33.

Shanxi and Taiyuan 1983
Shanxi Sheng Kaogu Yanjiusuo and Taiyuan Shi Wenwu Guanli Weiyuanhui. "Taiyuan shi Bei Qi Lou Rui mu fajue jianbao" [A report of the excavation of the Northern Qi tomb of Lou Rui at Taiyuan city]. *Wenwu* 1983.10: 1–23.

Sickman and Soper 1968
Sickman, Laurence, and Alexander Soper. *The Art and Architecture of China*, 3rd ed. Baltimore: Penguin Books, 1968.

Sinor 1990
Sinor, Denis. "The Establishment and Dissolution of the Türk Empire." In Denis Sinor, ed. *The Cambridge History of Early Inner Asia.* Cambridge, England: Cambridge University Press, 1990: 285–316.

Soper 1960
Soper, Alexander Coburn. "South Chinese Influence on the Buddhist Art of the Six Dynasties Period." *The Museum of Far Eastern Antiquities* (Stockholm) *Bulletin*, vol. 32 (1960): 47–112.

Stein 1921
Stein, M. Aurel. *Serindia: Detailed Report of Explorations in Central Asia and Westernmost China.* 5 vols. Oxford: Clarendon Press, 1921.

Thorp 1980
Thorp, Robert L. "Burial Practices of Bronze Age China." In Fong Wen 1980: 51–64.

Thorp and Bower 1982
Thorp, Robert L., and Virginia Bower. *Spirit and Ritual: The Morse Collection of Ancient Chinese Art.* Exh. cat. New York: The Metropolitan Museum of Art, 1982.

Trombert 2005
Trombert, Éric. "Un vestige vivant de la présence sogdienne en Chine de Nord: le vignoble du Shanxi." In de la Vaissière and Trombert 2005: 261–282.

Trubner 1962
Trubner, Henry. "An Unusual Chinese Tomb Figure." *Archives of the Chinese Art Society of America*, vol. 16 (1962): 99–101.

Tucker 2003
Tucker, Jonathan. *The Silk Road: Art and History.* Chicago: Art Media Resources, 2003.

Twitchett 1979
Twitchett, Denis, ed. *The Cambridge History of China.* Vol. 3, *Sui and T'ang China, 589–906*, part 1. Cambridge, England: Cambridge University Press, 1979.

Vainker 1991
Vainker, S. J. *Chinese Pottery and Porcelain: From Prehistory to the Present.* New York: George Braziller, Inc., 1991.

Valenstein 1989
Valenstein, Suzanne G. *A Handbook of Chinese Ceramics: Revised and Enlarged Edition.* New York: The Metropolitan Museum of Art, 1989. Available online: *MetPublications*. The Metropolitan Museum of Art. www.metmuseum.org/MetPublications.

Valenstein 1992
———. *The Herzman Collection of Chinese Ceramics.* New York: Stanley Herzman, 1992.

Valenstein 1997–1998
———. "Preliminary Findings on a 6th-Century Earthenware Jar." *Oriental Art*, vol. 43, no. 4 (Winter 1997–1998): 2–13.

Valenstein 2003–2004
———. "Western Influences on Some 6th-Century Northern Chinese Ceramics." *Oriental Art*, vol. 49, no. 3 (2003–2004): 2–11.

Valenstein 2007
———. *Cultural Convergence in the Northern Qi Period: A Flamboyant Chinese Ceramic Container: A Research Monograph.* New York: Department of Asian Art, The Metropolitan Museum of Art, 2007. Available online: *MetPublications*. The Metropolitan Museum of Art. www.metmuseum.org/MetPublications.

Wang Kelin 1979
Wang Kelin. "Bei Qi Kudi Huiluo mu" [The Northern Qi tomb of Kudi Huiluo]. *Kaogu xuebao* 1979.3: 377–402.

Watt et al. 2004
Watt, James C. Y., et al. *China: Dawn of a Golden Age, 200–750 AD.* Exh. cat. New York: The Metropolitan Museum of Art, 2004.

Wechsler 1979a
Wechsler, Howard J. "Relations with the Eastern Turks." In Twitchett 1979: 181–182.

Wechsler 1979b
———. "Foreign Relations." In Twitchett 1979: 219–224.

Whitfield 1999
Whitfield, Susan. *Life Along the Silk Road.* Berkeley and Los Angeles: University of California Press, 1999.

Whitfield 2004
———. ed. *The Silk Road: Trade, Travel, War and Faith.* Exh. cat. London: The British Library, 2004.

Wilkinson 1973
Wilkinson, Charles K. *Nishapur: Pottery of the Early Islamic Period.* New York: The Metropolitan Museum of Art, 1973.

Wood 1999
Wood, Nigel. *Chinese Glazes: Their Origins, Chemistry and Recreation.* London: A & C Black, 1999.

Wu Hung 2006
Wu Hung. "From the Neolithic to the Han." In Howard et al. 2006: 17–103.

Wu Hung 2010
———. *The Art of the Yellow Springs: Understanding Chinese Tombs.* London: Reaktion Books Ltd., 2010.

Xi'an 2004
Xi'an Shi Wenwu Baohu Kaogu Suo. "Xi'an shi Bei Zhou Shi jun shi guo mu" [The Northern Zhou stone sarcophagus tomb of Mr. Shi at Xi'an city]. *Kaogu* 2004.7: 38–49.

Xiong 2000
Xiong, Victor Cunrui. *Sui-Tang Chang'an: A Study in the Urban History of Medieval China.* Ann Arbor: Center for Chinese Studies, The University of Michigan, 2000.

Xiong 2006
———. *Emperor Yang of the Sui Dynasty: His Life, Times, and Legacy.* Albany: State University of New York Press, 2006.

Yamato Bunkakan 1995
Yamato Bunkakan. *Yamato Bunkakan meihin zuroku/Illustrated catalogue of selected masterpieces from The Museum Yamato Bunkakan collection.* Fourth edition. Nara: The Museum Yamato Bunkakan, 1995.

Yang Hong 2006
Yang Hong. "From the Han to the Qing." In Howard et al. 2006: 105–197.

Yang Xiaoneng 1999
Yang Xiaoneng, ed. *The Golden Age of Chinese Archaeology: Celebrated Discoveries from The People's Republic of China.* Exh. cat. London and New Haven: Yale University Press, 1999.

Yanshi 1999
Yanshi Shang Cheng Bowuguan. "Yanshi xian Goukoutou zhuanchang Tang mu fajue jianbao" [A report of the excavation of a Tang tomb at the Goukoutou brick factory, Yanshi county]. *Kaogu yu wenwu* 1999.5: 7–14.

Yates 2007
Yates, Robin D. S. "The Rise of Qin and the Military Conquest of the Warring States." In Portal 2007: 31–57.

Yin Shenping, Xing Fulai, and Li Ming 2000
Yin Shenping, Xing Fulai, and Li Ming. "Notes on the Excavation of the Tomb of An Qie." Trans. Bruce Doar and Susan Dewar. *China Archaeology and Art Digest: Zoroastrianism in China*, vol. 4, no. 1 (December 2000): 15–29. From *Zhongguo wenwu bao* (August 13 and August 30, 2000).

Zhang Bai 2008
Zhang Bai, ed. *Zhongguo chutu ciqi quanji/Complete collection of ceramic art unearthed in China.* 16 vols. Beijing: Science Press, 2008. Vol. 5, *Shanxi*.

Zhang Lintang and Sun Di 2004
Zhang Lintang and Sun Di, comps. *Xiangtangshan shiku: liushi haiwai shike zaoxiang yanjiu* [The Xiangtangshan caves: Research on the overseas carved stone sculptures]. Beijing: Waiwen Chubanshe, 2004.

Zhao Huijun and Guo Hongtao 2009
Zhao Huijun and Guo Hongtao. "Henan Yanshi san zuo Tang mu fajue jianbao" [A report of the excavation of three Tang tombs at Yanshi, Henan]. *Zhongyuan wenwu* 2009.5: 4–16.

Zhaoling 1988
Zhaoling Bowuguan. "Tang Zhaoling Changle Gongzhu mu" [The tomb of Tang Princess Changle at Zhaoling]. *Wenbo* 1988.3: 10–30.

Zhengzhou 2006
Zhengzhou Shi Wenwu Kaogu Yanjiusuo, ed. *Henan Tang sancai yu Tang qing hua/Tang ceramics made in Henan: The tri-colored and blue-and-white.* Beijing: Kexue Chubanshe, 2006.

Zhongguo Meishu Quanji 1989
Zhongguo Meishu Quanji Bianji Weiyuanhui, ed. *Zhongguo meishu quanji* [Compendium of Chinese art]: *Diaosu* [Sculpture]. 13 vols. Beijing: Wenwu Chubanshe, 1985–1989. Vol. 13, *Gongxian, Tianlongshan, Xiangtangshan, Anyang shiku diaoke* [Carvings in the Gongxian, Tianlongshan, Xiangtangshan and Anyang caves], 1989.

Zhongguo 1980
Zhongguo Shehui Kexueyuan Kaogu Yanjiusuo, ed. *Tang Chang'an cheng jiao Sui Tang mu / Excavation of the Sui and Tang tombs at Xi'an*. Beijing: Wenwu Chubanshe, 1980.

Zhongguo 1996
———. *Bei Wei Luoyang Yongningsi: 1979–1994 nian kaogu fajue baogao / The Yongningsi Temple in Northern Wei Luoyang: Excavations in 1979–1994*. Beijing: Zhongguo Da Baike Quanshu Chubanshe, 1996.

Zhou Dao 1964
Zhou Dao. "Henan Puyang Bei Qi Li Yun mu chutu de ciqi he muzhi" [The porcelains and tomb epitaph excavated from the Northern Qi Li Yun tomb at Puyang, Henan]. *Kaogu* 1964.9: 482–484.

Zhou Xiuqin 2009
Zhou Xiuqin. "Zhaoling: The Mausoleum of Emperor Tang Taizong." *Sino-Platonic Papers*, no. 187 (April 2009).

Zibo and Zichuan 1984
Zibo Shi Bowuguan and Zichuan Qu Wenhuaju. "Zibo Hezhuang Bei Chao muzang chutu qingli lianhua ci zun" [A porcelain lotus wine jar excavated from Northern Dynasties graves at Hezhuang, Zibo]. *Wenwu* 1984.12: 64–67.

Index

A

An Jia (d. 579), tomb of, 9
 four-sided, high-crowned hat, 10
 stone couch, 9
 tomb decoration, 9
analogous figures, 1–3
 Croës figure, 1, 1–2, 3, 43, 44
 Duan Boyang figure, 1, 3, 8
 Duan Boyang head, 1, 1–2, 3, 9–10, 44
 Musée Cernuschi figure, 1, 1–2, 3, 43, 44
 Royal Ontario Museum figure, 1, 2, 2–3, 3, 16n3, 43, 44

B

Buddhism, 35, 36, 37, 39, 44

C

ceramic technology, 17–23
 ceramic tomb figures, construction of, 17–18
 Croës and Musée Cernuschi figures and the Duan Boyang head, 17–18
 Rosenkranz and Royal Ontario figures, 17
 Chinese clays, 18
 documented Chinese porcelaneous tomb figures, 18–19. See also *mingqi* tomb figures: figures with porcelaneous bodies
 Duan Boyang figure, 1, 3, 8, 19, 30
 Duan Boyang head, 1, 1–2, 3, 9–10, 17–18, 19, 30, 44
 Jiajingkou figures, 8, 19, 21, 29
 Zhang Sheng figures, 8, 18–19, 29, 43, 44
 early northern Chinese lead-glazed earthenwares, 19
 early northern Chinese porcelaneous wares, 18
 glazed-and-painted earthenware tomb figures, 3, 8, 19. See also *mingqi* tomb figures: glazed-and-painted earthenware figures
 kiln-complexes, 20–21
 Gongyi kilns, 19, 21, 23n41, 38
 Liquanfang kilns, 20
 Tongchuan kilns, 20–21
 porcelain, xv, 18. See also porcelaneous ware
 porcelaneous ware, xv, 18, 21, 29, 43. See also porcelain
 sancai (three-color) glazes, 8, 15, 19, 20, 20–21, 23n35, 23n41, 30
Chang'an, Shaanxi, 2, 9, 11, 12n25, 15, 43. See also Xi'an, Shaanxi
China and the West, cultural influences, 39
 Buddhism, 35, 36, 37, 39, 44
 Silk Road, 8, 11, 39
 Steppe Route, 10, 39
 Western influences, 35, 36, 37, 39, 44
Chinese mortuary sculpture. See *mingqi* tomb figures
Croës figure.
 See analogous figures — ceramic technology: ceramic tomb figures, construction of — *mingqi* tomb figures: figures with porcelaneous bodies — ornamental motifs: motifs in the epaulettes — Sogdians

D

Duan Boyang (buried 661) and wife (buried 667), tomb of, 1, 4n4, 4n5
Duan Boyang figure.
 See analogous figures — ceramic technology: documented Chinese porcelaneous tomb figures — *mingqi* tomb figures: figures with porcelaneous bodies
Duan Boyang head.
 See analogous figures — ceramic technology: ceramic tomb figures, construction of *and* documented Chinese porcelaneous tomb figures — *mingqi* tomb figures: figures with porcelaneous bodies — Sogdians

E

epaulettes. *See* ornamental motifs
Eurasian nomads, 10, 14*n*50, 28, 44. *See also* Turkic Eurasian nomads
 Xianbei nomads, 10, 13*n*45, 28, 44
 Xiongnu nomads, 10, 15
Eurasian steppes, 10

G

Gongyi (Gong xian), Henan, 8, 18, 29. *See also* Jiajingkou tomb
Gongyi (Gong xian) kilns, Henan, 19, 21, 23*n*41, 38

H

hu ren Westerners, 2, 3, 7–8, 43, 44
 An Jia stone couch and tomb decoration, 9
 classic *hu ren* (non-Han Chinese Westerner), *xv*, 2, 7–8, 9, 15, 29, 44
 Rosenkranz figure, *xv*, 2, 7, 15, 29, 43, 44
 shenmu gaobi (deep eyes and high noses), 7

J

Jiajingkou figures.
 See ceramic technology: documented Chinese porcelaneous tomb figures — *hu ren* Westerners
Jiajingkou tomb, 8, 18, 19, 21, 29. *See also* Gongyi (Gong xian), Henan

M

mingqi (brilliant artifacts), 25, 31*n*2, 31*n*9
mingqi tomb figures, 25–33, 43, 44
 chronlogy
 in the Han dynasty, 27–28
 in the late Eastern Zhou dynasty, 26
 at the Qin Shihuangdi (r. 221–210 BC) necropolis, 26–27
 in the Six Dynasties period, 28
 in the Sui dynasty, 28–29
 in the Tang dynasty, 29–30
 mingqi figures with ceramic bodies
 earthenware figures, 7–8, 18, 26–30, 44
 glazed earthenware figures, 20, 28, 29
 glazed-and-painted earthenware figures, 3, 8, 15, 19, 28, 29–30, 43
 documentary glazed-and-painted Tang-dynasty tomb figures, 3, 19, 29–30

mingqi tomb figures: *mingqi* figures with ceramic bodies *(continued)*
 Musée Cernuschi figure, 1, 1–2, 3, 9–10, 17–18, 28, 29–30, 43, 44
 Sima Jinlong figures, 28, 44
 porcelaneous figures, 18–19, 21, 29, 30, 43, 44.
 See also ceramic technology: documented Chinese porcelaneous tomb figures
 Croës figure, 1, 1–2, 3, 9–10, 30, 43, 44
 Duan Boyang figure, 1, 3, 8, 19, 30
 Duan Boyang head, 1, 1–2, 3, 9–10, 19, 30, 44
 Idemitsu figure, 5*n*30, 30
 Jiajingkou figures, 8, 19, 29
 Rosenkranz figure, *xv*, 1, 1–2, 2, 3, 7, 15, 21, 29, 30, 43, 44
 Royal Ontario Museum figure, 1, 2, 2–3, 3, 10, 16*n*3, 28, 30, 43, 44
 Zhang Sheng figures, 8, 18–19, 29, 43, 44
 sancai (three color) glazed figures, 8, 15, 20, 21, 29, 30, 43
mortuary sculpture. *See mingqi* tomb figures
Musée Cernuschi figure.
 See analogous figures — ceramic technology: ceramic tomb figures, construction of — *mingqi* tomb figures: figures with ceramic bodies — ornamental motifs: motifs in the epaulettes — Sogdians

N

non-Han Chinese Westerners. *See hu ren* Westerners

O

ornamental motifs, 35–41
 dragon, *xv*, 2, 38, 39, 40*n*35, 44
 in the epaulets, *xv*, 36–37, 43
 five-petaled palmette, 37
 makara (confronting fish-like creatures), *xv*, 2, 36
 monster-mask, 2, 36–37
 pearled roundel, 36
 tasseled streamers issuing from an ornamental disk, *xv*, 35
ornamented belts, *xv*, 2, 3, 35, 43. *See also* Turkic-Eurasian nomads

R

religious beliefs, 25–26
Rosenkranz figure, *xv*, 1, 2, 3, 43, 44.
 See also ceramic technology: ceramic tomb figures, construction of — *hu ren* Westerners — *mingqi* tomb figures: figures with porcelaneous bodies — ornamental motifs: motifs in the epaulettes — Sogdians — Western wine-merchant figures
Royal Ontario Museum figure.
 See analogous figures — ceramic technology: ceramic tomb figures, construction of — *mingqi* tomb figures: figures with porcelaneous bodies — ornamental motifs: motifs in the epaulettes — Turkic Eurasian nomads

S

Sima Jinlong (d. 484), tomb of, 28, 44
 glazed-and-painted earthenware figures, 28
 non-Chinese (Xianbei Eurasian nomad) figures, 28, 44
Sogdiana, 8, 10, 11, 12*n*17, 12*n*20, 44
Sogdians, 8–10, 12*n*20, 13*n*35, 43, 44
 An Jia, 9, 10
 in Chang'an, 9
 Croës figure, 1, 1–2, 9–10, 43, 44
 Duan Boyang head, 1, 1–2, 9–10, 44
 ethnic Sogdians, 2, 8, 9–10, 29, 44
 four-sided, high-crowned hats, 1–2, 10, 29
 as merchants, 8, 11, 12*n*20
 metal ewers, 2, 4*n*15, 10
 Musée Cernuschi figure, 1, 1–2, 9–10, 43, 44
 rhyton, 2, 10, 15
 Rosenkranz figure, *xv*, 8, 9–10, 29, 43, 44
 Shi Wirkak (Lord Shi), 9
 and Turkic Eurasian nomads, 11, 44
 as viticulturists, 16
 as wine-merchants, *xv*, 43

T

Tang Taizong emperor, 3, 11, 14*n*51, 29. *See also* Zhaoling mausoleum
tomb figures. *See mingqi* tomb figures

Turkic Eurasian nomads, 3, 10–11, 44. *See also* Eurasian nomads
 China and, 11, 14*n*51, 44
 Eastern Turks, 11
 ethnic Turks, 3, 10–11
 ornamented belts worn by, 2, 3, 5*n*27, 43
 Royal Ontario Museum figure, 3, 4*n*24, 10, 16*n*3, 28, 30, 38, 40*n*35, 43, 44
 Uighur Turkic tribal confederation, 4*n*24
 Western Turks, 11

W

Western wine-merchant figures, *xv*, 15, 16*n*3, 43. *See also* wine
wine, 9, 15–16. *See also* Western wine-merchant figures

X

Xi'an, Shaanxi, 1, 2, 3, 9, 12*n*25, 20. *See also* Chang'an, Shaanxi

Z

Zhang Sheng (buried 595), tomb of, 8
 pair of earthenware *hu ren* Westerners, 8, 44
 pair of porcelaneous officials, 8, 18–19, 29, 43, 44
Zhaoling mausoleum, 3, 11, 29, 33*n*53. *See also* Tang Taizong emperor